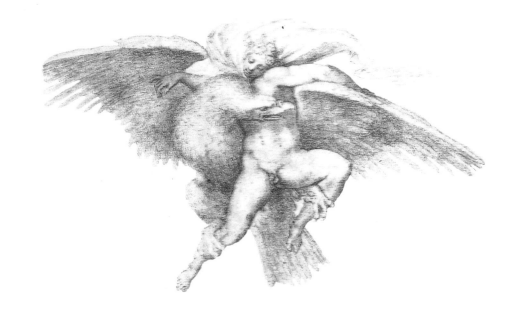

Michelagniolo

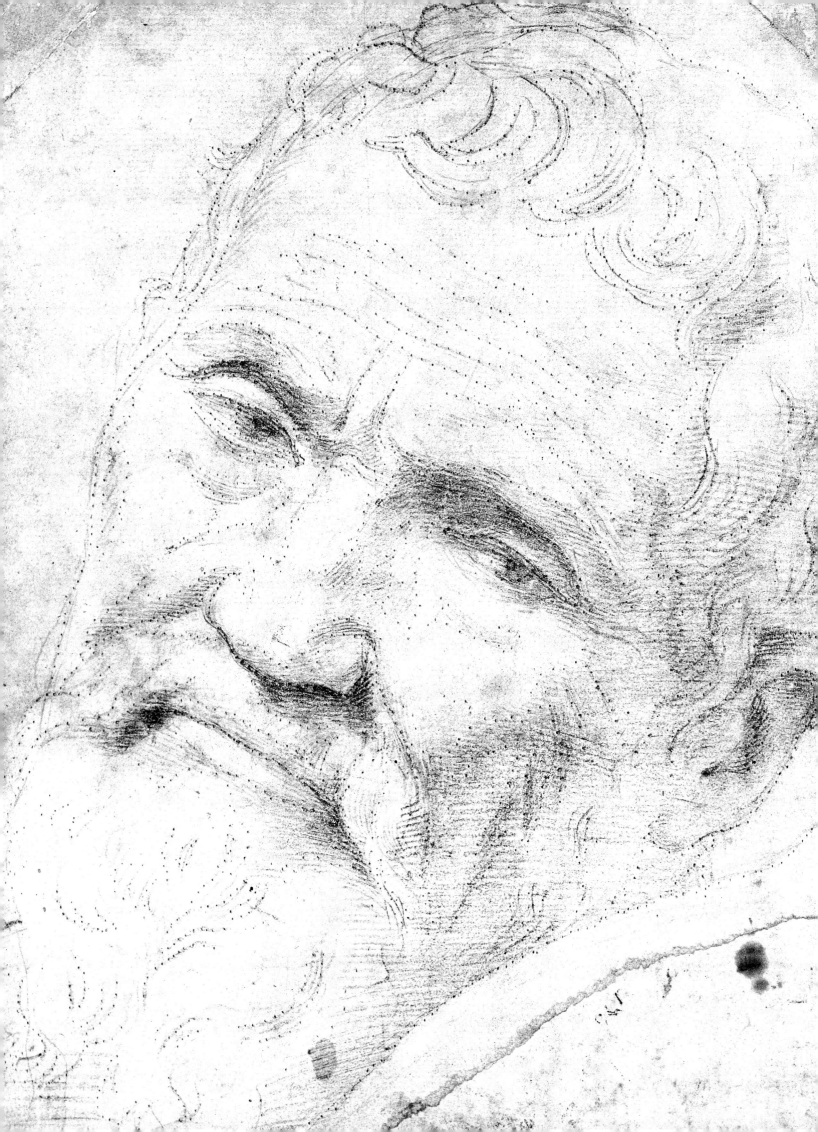

Gilles Néret

MICHELANGELO

1475–1564

TASCHEN

KÖLN LISBOA LONDON NEW YORK PARIS TOKYO

COVER:
David (detail), 1501–1504
Marble, height, 434 cm
Galleria dell'Accademia, Florence

ILLUSTRATION PAGE 1:
The Rape of Ganymede, ca. 1533
Black chalk, 19 x 33 cm
Fogg Art Museum, Cambridge (MA)

ILLUSTRATION PAGE 2:
Daniele da Volterra
Portrait of Michelangelo, ca. 1541
Black chalk, 29.3 x 20.9 cm
Teylers Museum, Haarlem

BELOW:
Young man naked, moving and making a gesture, 1496–1500
Pen and ink drawing, 37 x 23 cm
The British Museum, London

BACK COVER:
Marcello Venusti
Portrait of Michelangelo at the time of the Sistine Chapel, ca. 1535
Casa Buonarroti, Florence

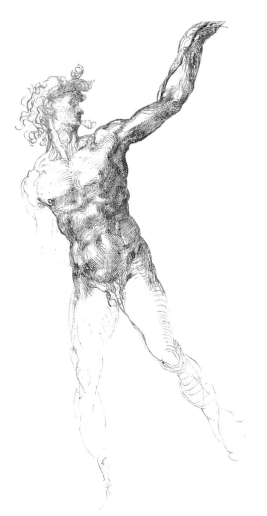

© 1998 Benedikt Taschen Verlag GmbH
Hohenzollernring 53, D-50672 Köln
Text and layout: Gilles Néret, Paris
Cover design: Angelika Taschen, Cologne
English translation: Peter Snowdon, Newcastle Upon Tyne

Printed in Germany
ISBN 3-8228-8272-0
GB

Contents

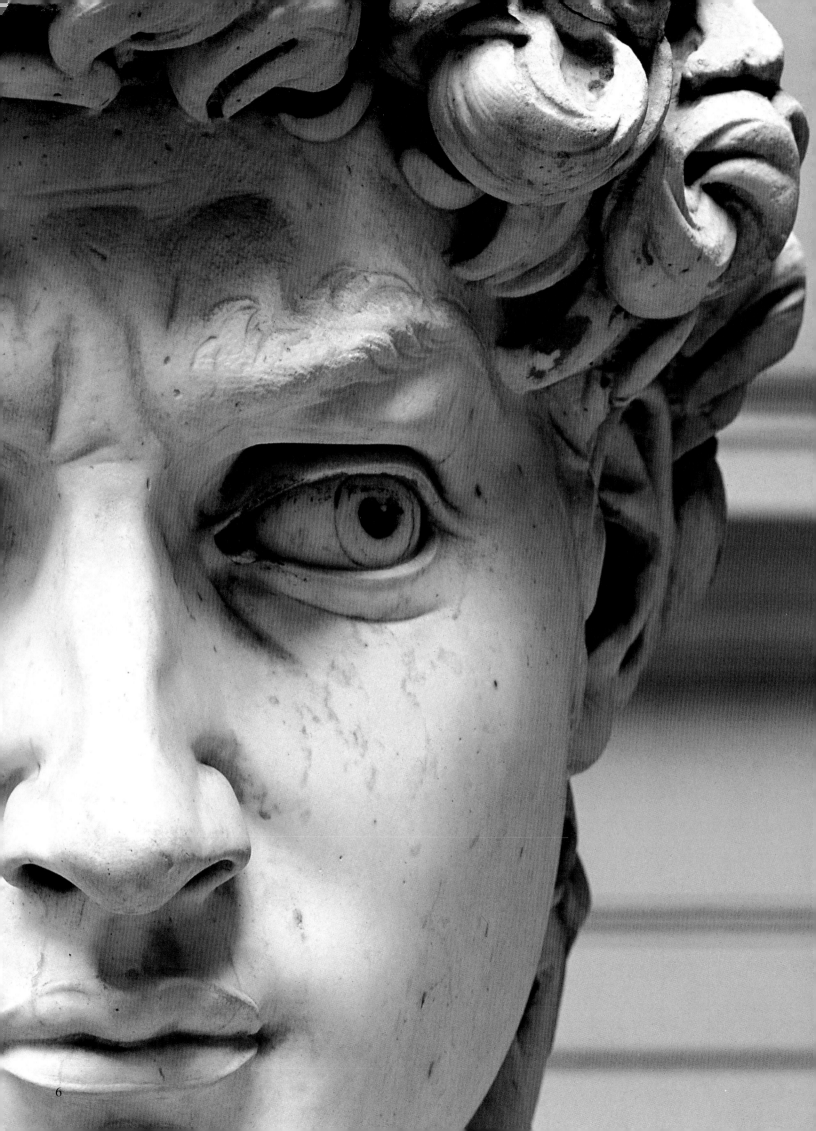

A stone cutter 1475–1505

Michelangelo never made any mystery of the fact that his entire life, from youth to old age, was consumed by passion. He seems to have been caught up in a whirlwind, like that of Dante's *Inferno*, which might sweep him up to Paradise or hurl him down to Hell. In the work that emerged from this vortex, the faces of handsome adolescent boys play a prominent role. Traditionally, this fact has been passed over in silence. Indeed, there were clumsy attempts to conceal it, out of a misplaced sense of the artist's dignity. Censorious morality, unable to comprehend Michelangelo's monumental creative strength, drew a veil over these figurations of a love at once carnal and mystic.

Yet in Michelangelo's work, passion and creation are born of the same fire. In one of his early poems, he wrote: "my food is only what burns and scorches, and in what brings others death I must find life". His poems themselves are, in his own words, made of "rugged, white-hot lava". The torment of this perpetual flame was such that he sometimes wished he had plucked out his eyes and thus denied himself knowledge of beauty: "If in my youth I had realised that the sustaining splendour of beauty with which I was in love would one day flood back into my heart, there to ignite a flame that would torture me without end, how gladly would I have put out the light of my eyes!…".

Now that we are no longer burdened by such hypocrisy, the edifice which Michelangelo sought to raise to his God stands revealed in all its glory – an edifice dedicated entirely to beauty. It is a triumph which has no equivalent in the history of art – a unique phenomenon, which has bred no heirs. Its success is due to the artist's ability to harness apparently conflicting forces. His mind united a feminine sensibility with a strength worthy of Hercules. His work enacts a constant struggle between matter and the principle of movement.

Only an artist who combined, as Michelangelo did, gifts and aspirations in equal part masculine and feminine, could succeed in this project without succumbing to its implied contradictions. Unlike the artists who preceded him, he did not seek a place in Heaven through faith, but aspired to raise himself up through the contemplation of beauty. This was a dangerous exercise, for the contemplation of human beauty can never be pursued with complete impunity – least of all the beauty of young men. It was both desirable and inevitable that Michelangelo's gaze be consumed by passion. Such was the ordeal through which he sought Heaven:

"…Love, burn, for whoever dies will have no other wings on which to fly to heaven". Giorgio Vasari saw this clearly: "The idea of this extraordinary man

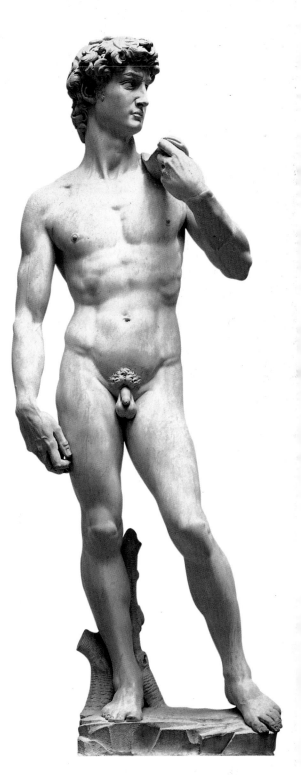

David, 1501–1504
Marble, height 434 cm
Galleria dell'Accademia, Florence

7

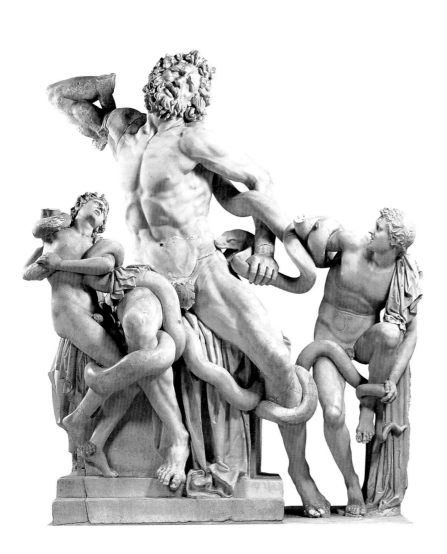

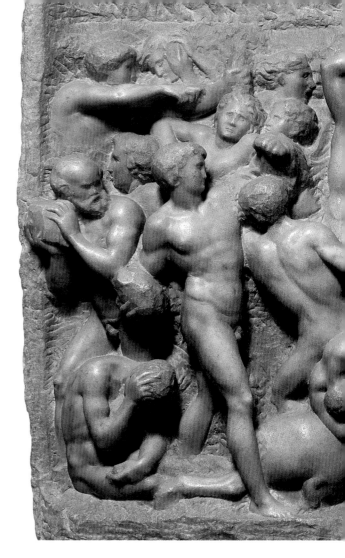

was to approach every composition as a function of the human body and its perfect proportions, in the prodigious diversity of its attitudes, making use both of the entire range of movements dictated by passion and the ecstasies of the soul". So much for those ridiculous critiques that accused him of substituting paganism for the true religion, provoking the fury of the decent Christian by exposing the naked human body in all its details. The human body as it emerged from the hands of the Creator was Michelangelo's true medium of expression, on the ceiling above the papal altar as elsewhere. Human beauty as represented in his works is a reflection of divine beauty, and its contemplation leads the soul inexorably towards God.

An artist as creative as Michelangelo is at his most pious when he depicts man's nakedness alongside the figures of the sacred, even when he dresses the Saviour Himself in "the handsome vestment of his nudity". This is the logic of the completely naked Christ that he sculpted in wood when he was still only seventeen, with all the tenderness of young genius. This is the logic too of the *David* (pp. 6–7), in which man is represented naked and defenceless; yet his oblique gaze and determined frown embody the *terribilità* characteristic of all Michelangelo's work. This adds a psychological dimension to the formal perfection of the sculpture. In accordance with a moral distinction common in the Middle Ages, Michelangelo played on the contrast between the tranquillity of the right side, which enjoys divine protection, and the vulnerable left side, which is exposed to the powers of evil. In doing so, he abandoned the traditional image of David as victor, inventing in its place a symbol that united *fortezza* (strength) and *ira* (anger). During the Renaissance, these two qualities were

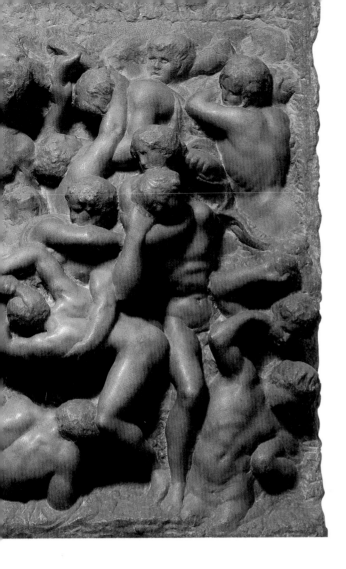

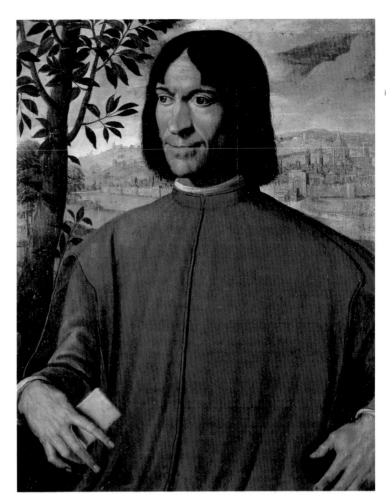

considered civic virtues, especially in the Florentine republic, which had commissioned the statue.

The same logic lies behind the *Tondo Doni* (pp. 10–11). Here the image of the Holy Family is far from religious, though the figures are imprinted with a gentle gravity and a sense of pride akin to the sacred. Why, then, does this garland of ephebes, of *garzoni,* appear in the background? They are there simply for the pleasure of the painter, for whom nothing is more natural than to render homage to the beauty he prefers. These *Ignudi* are still adolescents; grown to manhood, they reappear on the vault of the Sistine chapel. They are not angels shorn of their wings. These boys are the painter's companions. They have no place in the midst of these highly significant biblical scenes, unless to bear witness, once again, to their own ambiguous beauty.

Michelangelo was fascinated by the beauty of the body and the face. It was only when he fell in love with Tommaso dei Cavalieri, renowned for both "his incomparable beauty" (Benedetto Varchi) and the quality of his mind, that he finally mastered his own quest. Only then was he able to forge a link between "*la forza d'un bel viso*" and the beauty of the soul. Thenceforth, there could be no shame in Socrates' words: "He who loves the body of Alcibiades does not love Alcibiades but something which belongs to Alcibiades, while he who loves Alcibiades' soul truly loves Alcibiades himself". As Pierre Leyris observes, "over and beyond his face and body, it is the young Roman's soul that he aspires to contemplate without end, to espouse so closely as to become one with it".

This love equally divided between body and soul was a source of both suffering and creative energy – inseparable companions that underpin Michel-

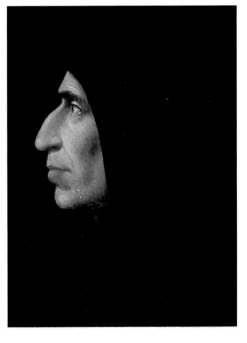

Fra Bartolomeo
Portrait of Savonarola, ca. 1497
Oil on wood, 53 x 47 cm
Museo di San Marco, Florence

ABOVE:
Anonymous
Portrait of Lorenzo il Magnifico with a panorama of the city behind him, Florence, ca. 1485

9

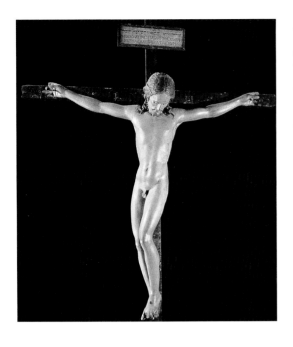

angelo's entire œuvre. Driven by "this heart of sulphur and this flesh of tow" – god-given, as he says in a famous sonnet – he constantly succumbed to the temptations of the flesh. The names of young men litter his biography. Their owners doubtless occupied the same place in his life as the *garzoni* for whom Botticelli and da Vinci were both famous. But it was only because he was "a man of sin, of grave and repeated sins", as one poem painfully insists, that he was able to suffer and create.

André Chastel discusses the different ways in which the artists of the Renaissance experienced their difference and creatively transformed it. "For Raphael, beauty was the promise of happiness, for Leonardo the solicitation of a profound mystery. For Michelangelo, it became a source of torment and moral distress. No one went so far in exploring the intuition – indeed, the declared principle of the Florentine Platonists – that the attraction of beauty, through the impulse of love that thrills through the entire being, is the creative principle par excellence, and the only one worthy of a noble soul. But at the same time, no

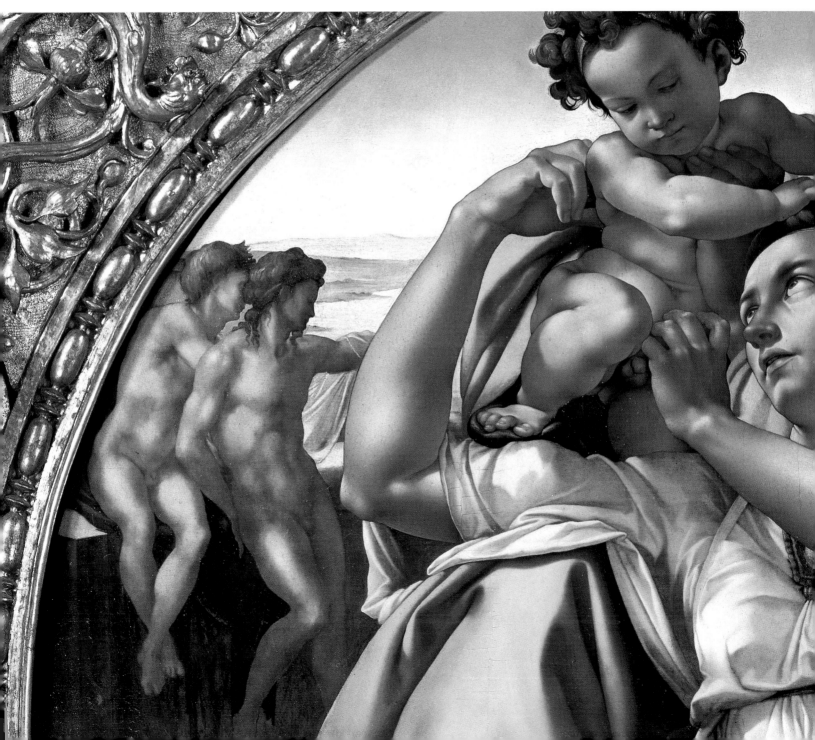

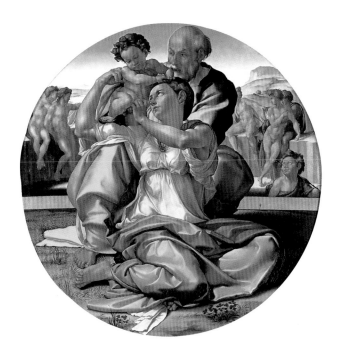

Not the most orthodox of Holy Families: the
Madonna stretches her hand out towards her
son's sex, while the artist introduces a garland
of naked and distinctly pagan boys into what
is, ostensibly, a religious painting.

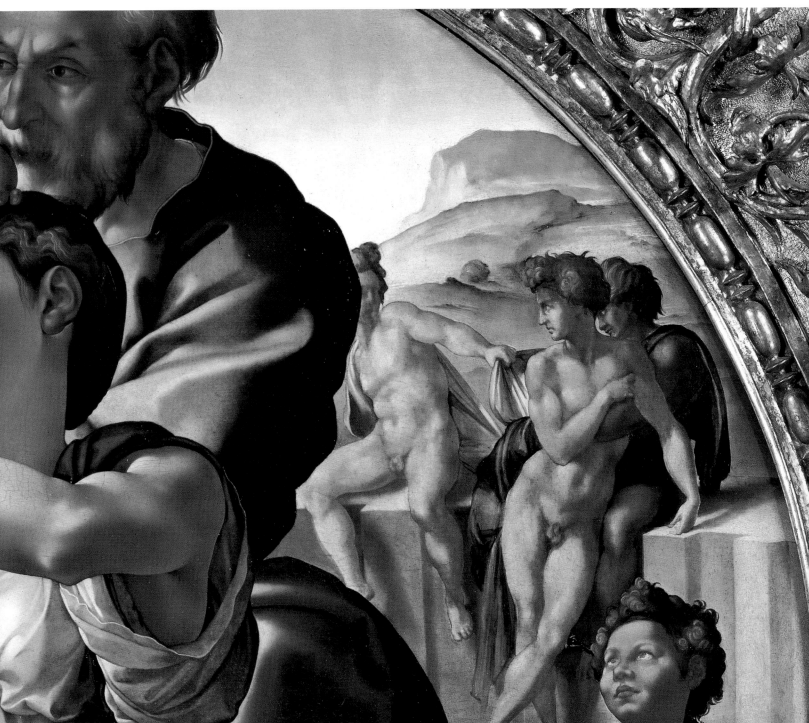

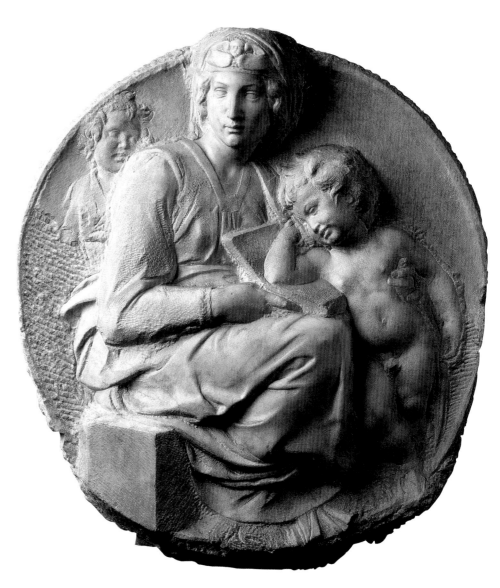

ABOVE:
Saint Proculus, 1494–1495
Marble, height 58.5 cm
Basilica of San Domenico, Bologna

RIGHT:
Tondo Pitti – Virgin and Child with the
young St John, 1503-1504
Low relief in marble, diam. 85.5 x 82 cm
Museo Nazionale, Bargello, Florence

one felt as painfully as Michelangelo the difficulty of detaching beauty from its sensual forms and sublimating love in its entirety".

Michelangelo used to joke that he had acquired his vocation along with the milk that he drank at his mother's breast. He was born on 6 March 1475 at Caprese, in Casentino. His family, the Buonarroti Simoni, are mentioned in the Florentine chronicles as early as the 12th century. He was entrusted to a wet nurse, who was the wife of a stone cutter in Settignano. Doubtless the fact that he took his first steps among the village craftsmen helped lay the foundations of his adult passion for working in stone. At school in Florence, he was only interested in drawing. At first, this angered his father, who had a low opinion of artists, and would frequently administer beatings to try to change his son's mind. But he soon gave in and allowed the boy to pursue his chosen profession. The first studio Michelangelo entered was that of Domenico Ghirlandaio, with whom he soon fell out. The young apprentice had already discovered that, for him, painting was unworthy of the term 'art'. His genius drew him to sculpture. Famous today for the frescoes of the Sistine Chapel, he never sought to paint, and did so only when forced. He therefore chose to move to the studio of Giovanni di Bertoldo, a pupil of Donatello, who was director of a school of sculpture and of Lorenzo de' Medici's collection of classical antiquities (p. 9). Both institutions were sited in the gardens of San Marco. There Michelangelo was able to pursue two of his greatest passions: the tradition of Donatello, and the study of the great classical models. What was more, he gained the acquaintance of the prince and

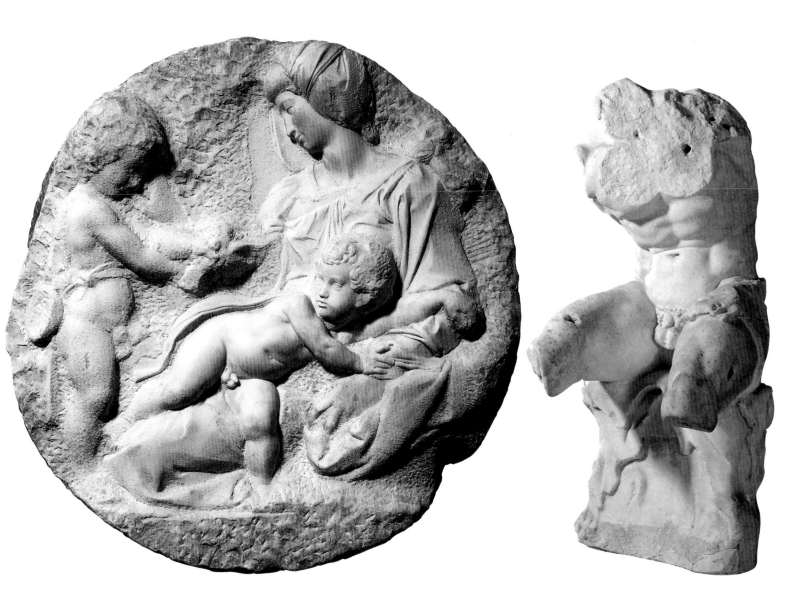

the intellectual elite of the city. As a result, he suddenly found himself at the centre of the Renaissance project, surrounded by humanists and poets, and on familiar terms with the finest flower of Italian civilisation. Lorenzo took a liking to him, and soon Michelangelo was living in the prince's palace and eating at his table. The young artist was plunged into a world whose taste for the pagan marked him for life. There he could drink his fill of the ancient culture and gorge himself on the heroic forms of Greek art; all of this he translated into his own work, infusing it with an unbridled violence that was all his own.

Thence came *The Battle of the Centaurs* in the Casa Buonarroti (pp. 8–9), a mêlée of naked men forming a typically Michelangelesque vision of beauty, with their athletic forms and movements. At the same time, another conflict had broken out within the artist; it was to last almost throughout his life. How could those two opposing worlds – the pagan figures which attracted him, and the Christian faith to which his soul held fast – be reconciled? In this struggle lay the seeds of his torment and his œuvre.

On the one side were ranged his father, "an old-fashioned man, who feared God", his elder brother Lionardo, who took Dominican orders at Pisa, and Giro-lamo Savonarola (p. 9), who was just then beginning to preach his inflammatory sermons on the Apocalypse in Florence. On the other, there stood the love of beauty and of nature, which drove him to study anatomy in corpses he would spend hours dissecting until finally their stench made him ill. Savonarola's fiery sermons, in which he called down God's justice on the Pope and the princes of

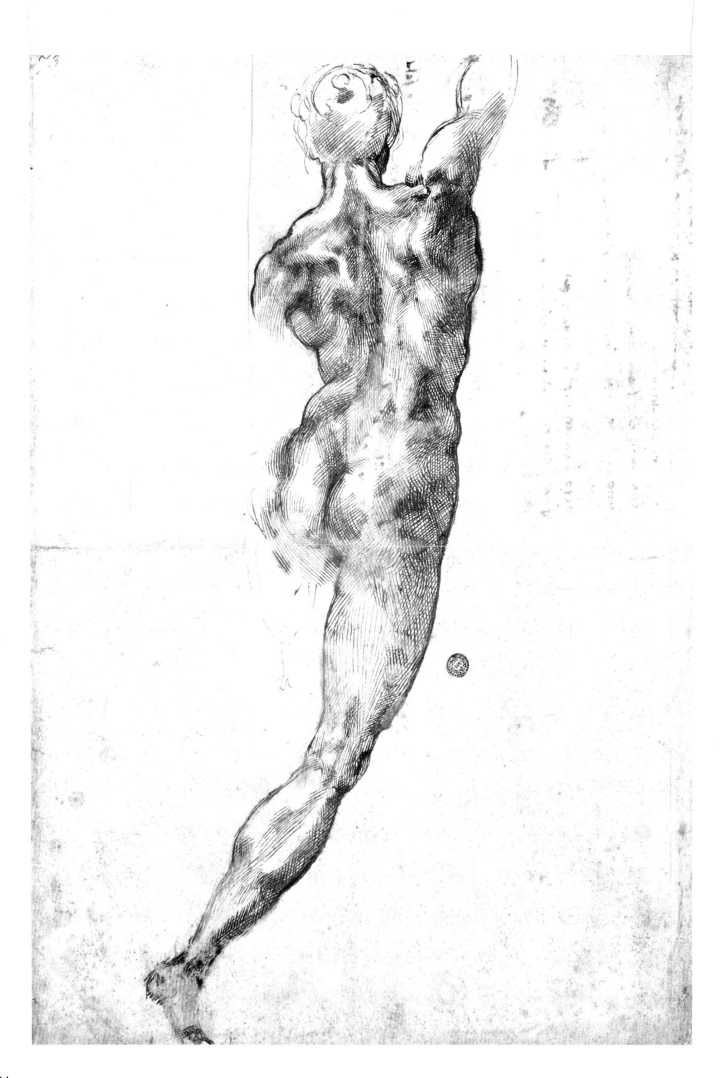

14

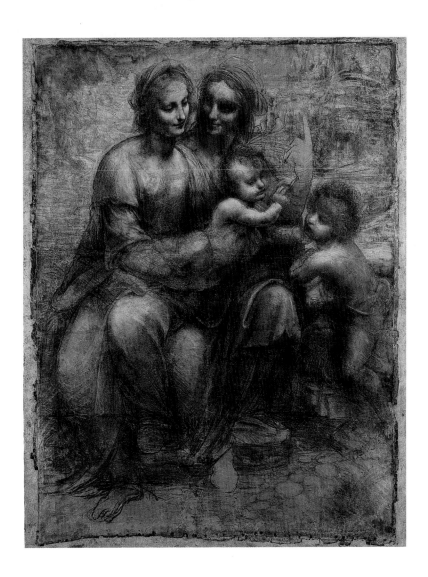

this world, were not unsympathetic to Michelangelo. But when fear of the frail preacher took hold of Florence, Michelangelo sought refuge in Venice. From Venice he went to Bologna; the angel he sculpted there for the tabernacle of San Domenico might be a marathon runner under starter's orders disconcertingly equipped with wings.

Between 1492 and 1497, while the tragedy of Savonarola was unfolding, Michelangelo's work was at its most pagan. A clear testimony of his deep insight into classical sculpture, his *Bacchus* possesses a sensuality of line worthy of Hellenistic masters. Florence was still plunged in mystic fervour when he made his *Cupid Sleeping*, which he sold as a fake antique to the Cardinal Riario, for his collection of Greek scupture (1496). Savonarola, who was put to death at the stake in 1498, attributed a single function to art: religious edification. Michelangelo despised such art. He felt closer to God carving the harmonious forms of a beautiful body than giving expression to a psychological or moral attitude. Pious artworks were only suitable "for women, especially old or very young women, as well as for monks, nuns and certain aristocrats, who are insensible to true harmony".

Even the *Pietà* in St Peter's (pp. 16–18), which he began in the year of Savonarola's death, while more religious in subject than other works from this period, is closer to Michelangelo's beloved Greek pantheon than to the desolate Virgins whose cries of despair had been painted by Donatello, Luca Signorelli and Andrea Mantegna. The *Pietà* is dominated by the calm beauty of the child-

ABOVE:
Virgin and Child, ca. 1504
Marble, height 128 cm
Onze Liewe Vrouw, Bruges

LEFT:
Leonardo da Vinci
The Virgin with the child Jesus, St Anne and St John the Baptist, ca. 1498
Charcoal with white highlights on board,
141.5 x 104.6 cm
National Gallery, London

PAGE 14:
Male nude seen from behind, ca. 1504
Pen and ink drawing over black chalk,
40.9 x 28.5 cm
Casa Buonarroti, Florence

Probably a study for one of the soldiers in *The Battle of Cascina.*

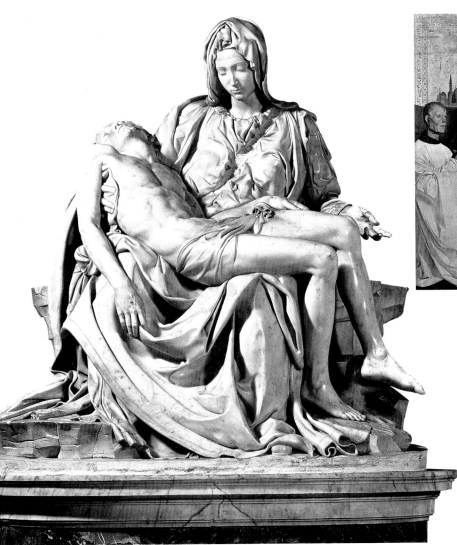

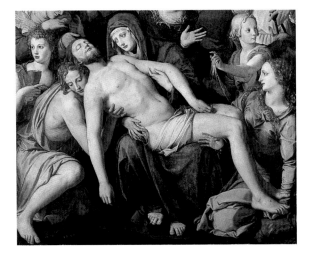

like Madonna. The body of Christ lies across her knees like that of a sleeping infant. As ever in Michelangelo's work, beauty takes precedence over tragic declamation. Where other artists use a similar pose, they infuse it with the tension of pain and suffering, for example in paintings by Agnolo Bronzino (p. 16) or Enguerrand Quarton (p. 16). Michelangelo's own comments on the *Pietà* show how his mysticism depended on the beauty with which he infused his creations. On the contrast between the eternal youth of the Virgin and the adulthood of Christ, he told Ascanio Condivi: "Don't you know that chaste women keep their freshness much better that those who are not chaste? Even more so a virgin whose body has never been troubled by the slightest immodest desire...". As for the son, no miracle there; incarnated as a man, he grew old. There is no need to hide his humanity behind his divinity: "So do not be surprised", he concludes, "if for these reasons, I have represented the Most Holy Virgin, Mother of God, much younger than her years would suggest, and if I have left the Son the age he was".

The two greatest artists of the Renaissance, Leonardo da Vinci and Michelangelo, were never close. Leonardo was interested in everything, but never took sides. Michelangelo, on the other hand, preyed on by his changing passions, hated those who, like his rival, had no faith and no allegiance. This aversion several times found public expression. When they finally met head on, in a battle of *Battles*, the result was one of the turning points of the Renaissance. In 1504, the Signoria of Florence set them to undertake a joint commission: the

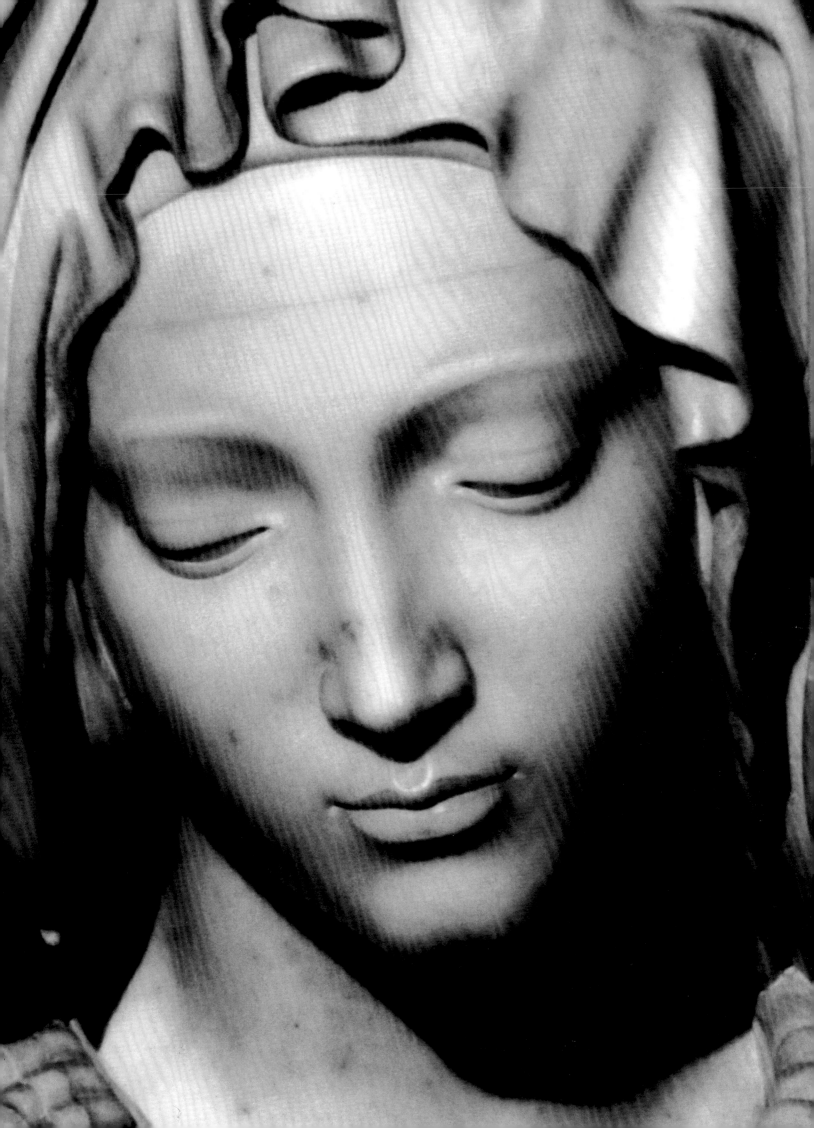

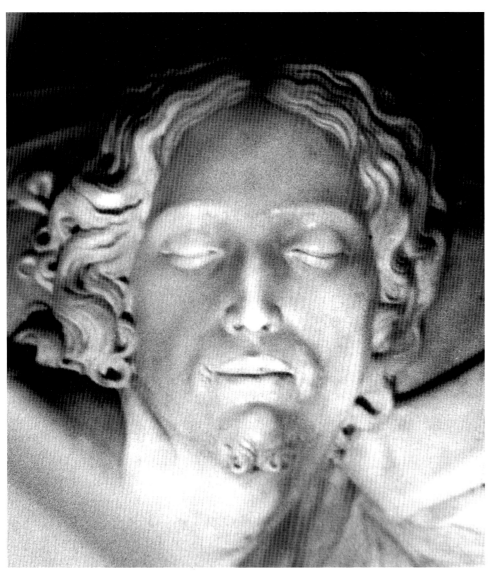

PAGE 19:
The Entombment, unfinished, now attributed to Michelangelo, ca. 1504
Oil on wood, 161.7 x 149.9 cm
National Gallery, London

LEFT:
Pietà, detail of Christ's face

BELOW:
Young girl kneeling, looking towards the right, study for the figure bottom left in *The Entombment,* ca. 1503–1504
Black chalk and two different shades of ink, 27 x 15 cm
Musée du Louvre, Cabinet des dessins, Paris

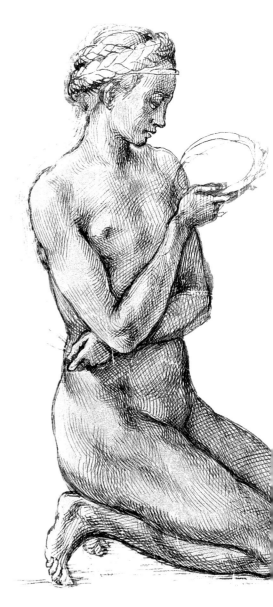

decoration of the Great Council Hall. Leonardo worked on the *Battle of Anghiari*, Michelangelo painted the *Battle of Cascina* (p. 20). Florence was immediately divided into two camps passionately supporting one or the other. By an irony of fate, neither of these two works – which played a central role in the history of art – long survived their makers. Leonardo's fresco was inadvertently destroyed by his own hand; he had invented a new kind of varnish, which dripped off onto the floor, taking the paint with it. As for Michelangelo's cartoon, it perished in the civil conflict of 1512.

Ephemeral as they were, the two cartoons made a crucial impact on painting throughout Italy. Leonardo had depicted his battle with characteristic lucidity, but the result was coldly analytical. Michelangelo, following his instincts, had chosen to ignore the historical anecdote that was his ostensible subject, replacing it with a crowd of naked men bathing, executed with great freedom.

Seeking to express the violent movements and attitudes of the combatants – what Michelangelo himself described as "the bestial folly" of war – he chose an episode from Villani's *Chronicle* in which the Florentine soldiers learn that the enemy is approaching while they are bathing in the Arno. They scramble to pull on their clothes and pick up their weapons for the fight. This scene allowed Michelangelo to indulge his favourite motif – naked men caught in violent and unusual poses. It also allowed him to demonstrate not only his perfect know-

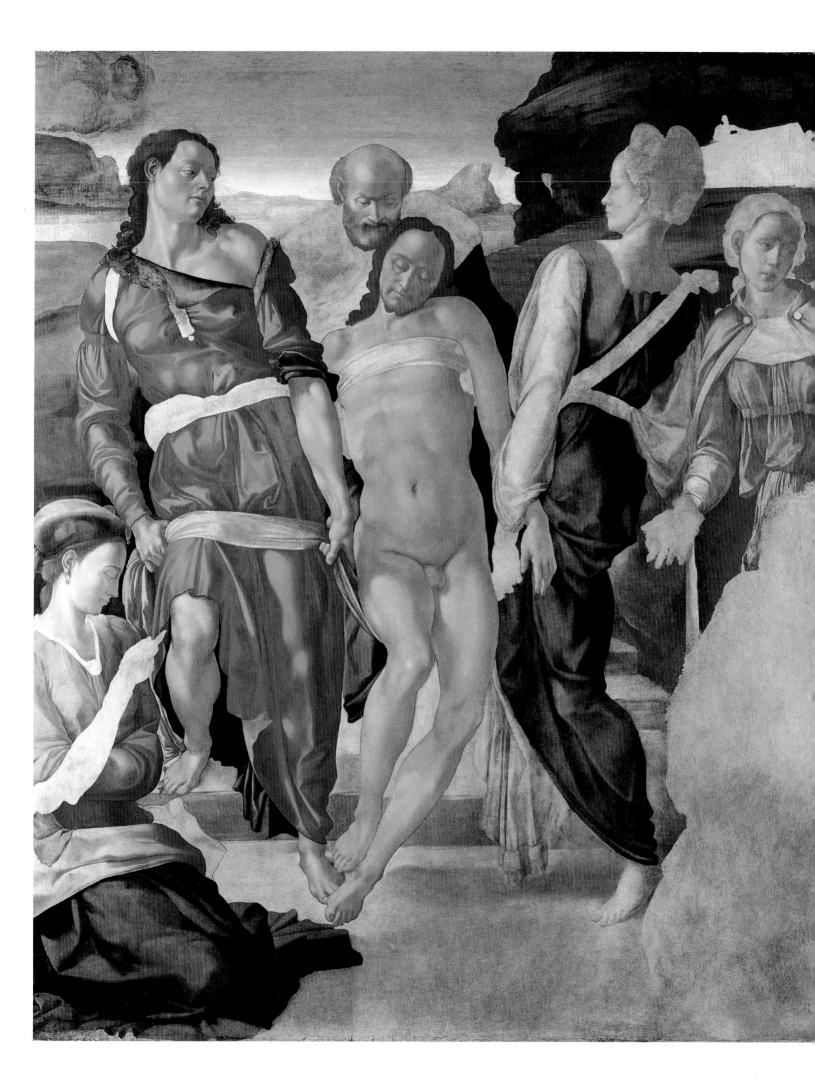

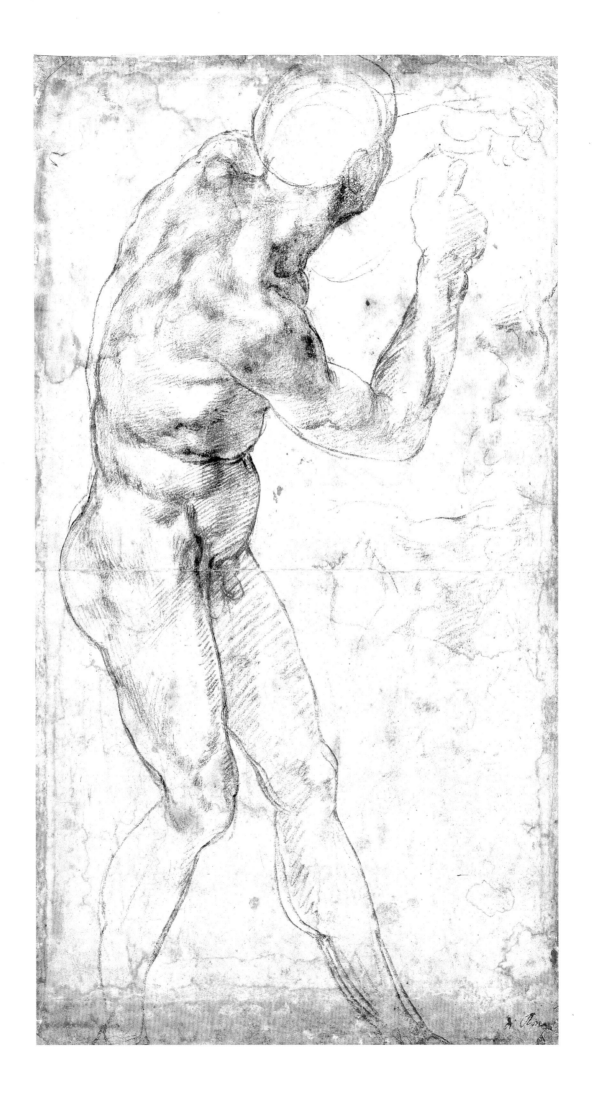

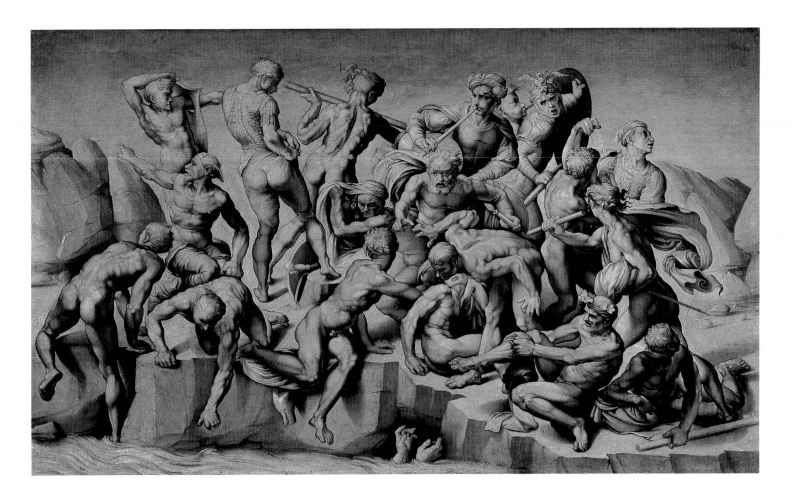

ledge of human anatomy, but the expressive intensity with which he could define figures and gestures. This intensity was something completely new in the art of the Renaissance. It was the start of an aesthetic revolution.

Despite Da Vinci's excessively analytical approach and Michelangelo's tendency to abstraction, these two works set a new and authoritative standard for the treatment of such subjects. Raphael copied them, Fra Bartolomeo drew inspiration from them, and Andrea del Sarto spent many long hours studying them. Sweeping away the charming primitives who had preceded them – from Pinturicchio and Signorelli to Perugino – these paintings imposed a universal tyranny. As Benvenuto Cellini said in 1559: "Michelangelo's cartoon was placed in the Medici Palace, and Leonardo's in the Sala del Papa [at Santa Maria Novella]; for as long as they were on show there, they were the school at which the whole world came to study". But not everyone can equal Leonardo and Michelangelo. Romain Rolland rightly mourned the "sudden fall from grace, like a decree of banishment" that befell primitive painting: "so much delicacy, elegance and energy, sacrificed to a beauty which was, no doubt, superior, but of which few were capable. Instead of broadening the minds of their followers, admiration for Da Vinci and Michelangelo seems to have rendered them narrow and intolerant".

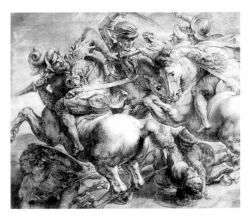

Peter Paul Rubens
The Episode of the Standard from the Battle of Anghiari, ca. 1600
Drawing after Leonardo da Vinci,
45.2 x 63.7 cm
Musée du Louvre, Cabinet des dessins, Paris

ABOVE:
Aristotile da Sangallo
The Battle of Cascina, after Michelangelo,
central section of the cartoon, ca. 1542
Oil on panel, 76.5 x 130 cm
Holkham Hall, Norfolk

PAGE 20:
Male nude and two studies for **The Battle of Cascina,** 1504–1506
Black chalk with white highlights,
40.5 x 22.6 cm
Teylers Museum, Haarlem

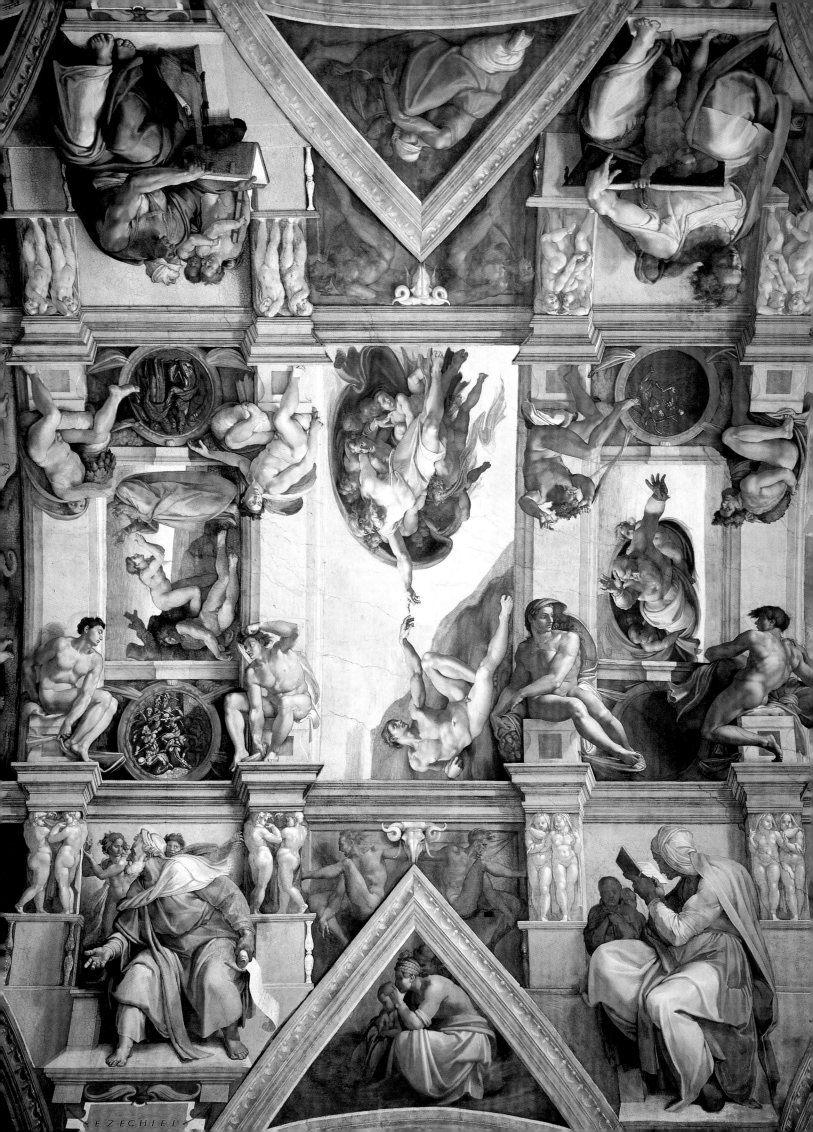

EZECHIEL

The Pope and the Artist 1505–1513

Michelangelo detested oil painting. He said it was only "suitable for women …
or for idlers like Sebastiano del Piombo". Like Plato, he felt that it was less vir-
ile and less pure than sculpture; seductive, and possessed of an "illusory magic"
that imitated "the appearance of things", it yet created only phantoms. In particu-
lar, he despised it for prizing the the attractions of colour over those of the idea.

What would he have thought of the Impressionists? Following Plato once
again, Michelangelo held that landscape painting should be forbidden, being
nothing but "a vague and deceitful sketch, a game for children and uneducated
men …". He hated portraiture too, in which he saw only "flattery of idle curios-
ity and of the imperfect illusions of the senses". In all these judgements, he was
diametrically opposed to the majority of the Italian artists of his day, and to the
naive faith of that pious German burger, Dürer. At almost the same time, in 1513,
Dürer was writing: "The art of painting is employed in the service of the
Church, to show the sufferings of Christ and of many other good models; it
also preserves the appearances of men after their death".

Not content to disparage painting, Michelangelo asserted its inferiority to
sculpture. In a letter to Benedetto Varchi in 1547, he wrote: "The more painting
resembles sculpture, the better I like it, and the more sculpture resembles paint-
ing, the worse I like it. Sculpture is the torch by which painting is illuminated,
and the difference between them is the difference between sun and moon". He
added, in a treacherous aside that seems to have been aimed at his rival Da
Vinci: "If he who wrote that painting was more noble than sculpture shows the
same understanding in other things as in that remark, my servant girl could do
better".

Thus we can imagine the affliction he must have felt when, in 1508, he was
obliged to fresco the ceiling of the Sistine Chapel for Pope Julius II. A thousand
square metres awaited him; there were some 300 figures to compose. He worked
on it from 1508 to 1512, alone, reluctant and relentless. Michelangelo suffered
martyrdom in this Herculean task. His bitterness and utter dejection found ex-
pression in his letters: "This is not my profession", he complained. "I am wast-
ing my time, and all for nothing. May God help me!" It is astounding that an
artist who disliked painting as much as Michelangelo should have achieved uni-
versal glory in that art. (See also the sonnet on the artist busy with his painting,
p. 24).

Yet this episode had begun as an idyll. In 1505, Julius II summoned
Michelangelo to Rome to assist him in his grandiose projects. In particular,

Raphael
Portrait of Pope Julius II, ca. 1511–1512
Oil on panel, 108 x 80.7 cm
National Gallery, London

ABOVE:
Giuliano Bugiardini (attributed to)
*Portrait of Michelangelo at the time of the
Sistine Chapel*
Drawing

PAGE 22:
Partial view of the frescoes in the Sistine
Chapel which cover 1000 m² and depict ap-
proximately 300 figures. They absorbed all
Michelangelo's energy as he worked on them
alone and unaided, from 1508 until 1512.

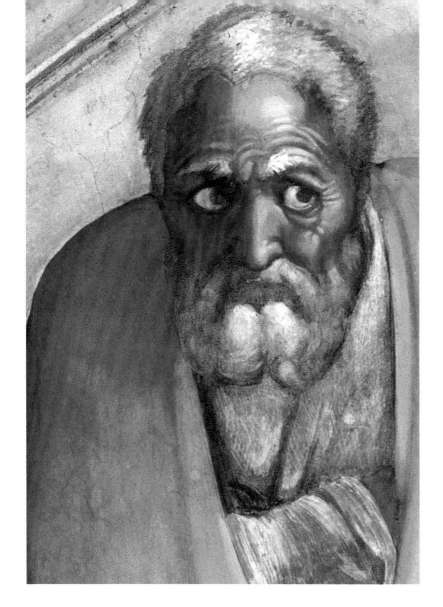

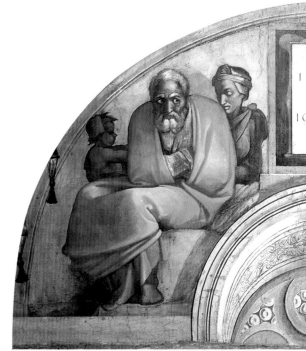

Manuscript of a sonnet by Michelangelo, 1509–1510, accompanied by a sketch in brown ink, 28.3 x 20 cm
Buonarroti Archives, Florence

In this sonnet, the artist mocks the state to which he has been reduced as he lies on his scaffolding to paint, forced to adopt uncomfortable and unnatural poses. In the accompanying sketch, he depicts himself with one arm raised and his head tilted backwards, painting a diabolical form on the ceiling of the Sistine Chapel

Julius envisaged a mausoleum for himself, to be built within the Vatican basilica. He was following in the footsteps of the Roman Emperors, and planning a programmatic restauratio of the papal city as a prelude to political reform.

The Pope and his artist were perfectly matched, in either sense. Both were proud, violent men, their minds seething with vast conceptions. Michelangelo submitted to Julius the project of a grandiloquent mausoleum, a vast work incorporating more than forty statues, some of them colossi, and numerous bronze reliefs. The Pope was so pleased, that according to Condivi, "he sent him straight to Carrara (April 1505), with orders to cut as much marble as necessary… Michelangelo spent more than eight months in the mountains, with two servants and a horse". While he was there, he fell into a state of superhuman exaltation. In his ecstasy, he even imagined sculpting an entire mountain. When the blocks arrived in St Peter's Square, "the mass of the stones was so great, that the people were astounded and the Pope overjoyed".

But Julius II could be fickle, and his advisers included men like Donato Bramante, who saw Michelangelo as their rival. Without warning, Julius II abandoned the project. The outraged Michelangelo fled Rome on horseback, and refused to return. They did not meet again until Julius II made his triumphant entry into Bologna in 1506. Their reconciliation owed nothing to goodwill: "I was forced, a rope around my neck, to go and ask his pardon", Michelangelo noted later. Meanwhile, Julius II had a new idea – as perilous as it was

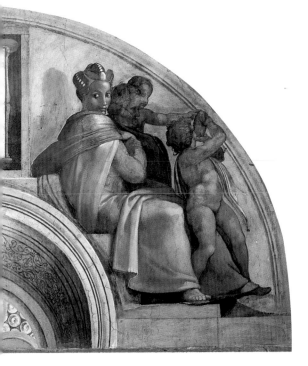

"In this difficult position I've given myself a goitre – as does the water to the peasants of Lombardy, or anyway of some country or another – for it shoves my stomach up to hang beneath my chin.

My beard points to heaven, and I feel the nape of my neck on my hump; I bend my breast like a harpy's, and, with its non-stop dripping from above, my brush makes my face a richly decorated floor.

My loins have gone up into my belly, and I make my backside into a croup as a counterweight; and I cannot see where to put my feet.

In front my hide is stretched, and behind the curve makes it wrinkled, as I bend myself like a Syrian bow.

So the thoughts that arise in my mind are false and strange, for one shoots badly through a crooked barrel.

Defend my dead painting from now on, Giovanni, and my honour, for I am not well placed, nor indeed a painter."

Michelangelo: Tailed sonnet (5), for Giovanni da Pistoia, 1509–1510. From *Michelangelo: The Poems,* translated by Christopher Ryan, J. M. Dent, 1996

ABOVE:
Lunette of *Jacob and Joseph* and two details, 1511–1512
Fresco, 215 x 430 cm
Sistine Chapel, Vatican

Genealogical sequence of the ancestors of Christ.
From the Gospel according to Matthew (1,16): "Jacob [left] begat Joseph, the husband of Mary [right], of whom was born Jesus, who is called Christ".

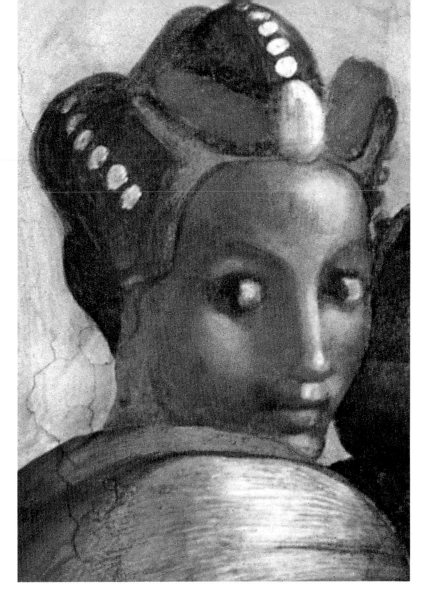

unexpected. Michelangelo hated painting and knew nothing about fresco technique; Julius ordered him to fresco the ceiling of the Sistine chapel. This was a trap, suggested to the Pope by Bramante and other rivals. If Michelangelo refused, he would again quarrel with Julius II. If he accepted, surely the results would not bear comparison with the *Stanze,* on which Raphael had begun work that year (1509) and in which his art had already reached a new and unprecedented level of mastery. Michelangelo would have to surpass him or be crushed by the comparison. The sculptor did all he could to avoid the "honour". He protested that painting was not his art and that failure was inevitable. He even suggested that Raphael replace him. In vain. The Pope stood firm, and Michelangelo could do nothing but grit his teeth and set to work.

This immense undertaking was begun on 10 May 1508. Michelangelo insisted on reinventing the techniques of fresco painting from scratch. He refused to use the scaffolding that Bramante had erected. He refused the help of experienced fresco painters who had been brought from Florence to advise him. Instead, he simply locked himself in the chapel with a couple of workmen. There he decided he would paint not just the ceiling, but the walls as well. Even the old frescoes that had long adorned the chapel would have to go.

At the centre of the ceiling are the nine *Scenes from Genesis.* They begin with the depiction of an athletic God carried aloft on a cloud of spirits. He seeks to overcome his solitude by creating man in his own image (pp. 40–41); he then

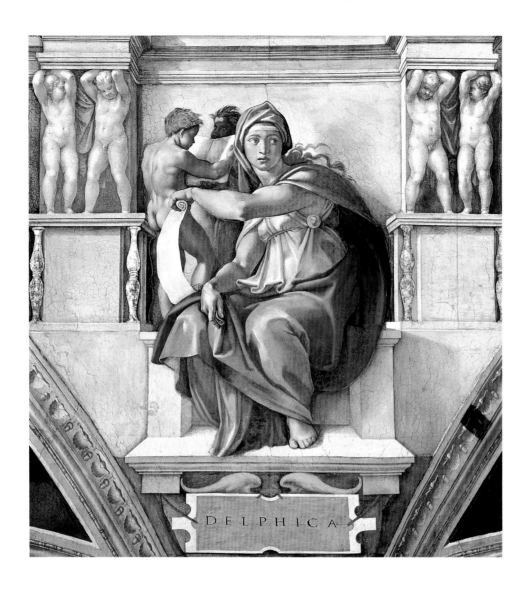

DELPHICA

First bay of the vault, ***The Sybil of Delphi unrolling a parchment scroll and apparently turning towards the crowd to read it,*** 1509
Fresco, approx. 350 x 380 cm
Sistine Chapel, Vatican

PAGE 27:
Sibyl of Delphi, detail from the face

creates a woman no less powerful than man, for she carries within her the entire human race. These first human beings are veritable temples of flesh. They have torsos likes tree trunks, arms like pillars, and the most formidable thighs. They are already big with the passions and crimes whose punishments will be depicted in the sequel: *The Temptation, Original Sin* (pp. 34–37), and *The Flood* (pp. 29–33).

At the meeting of the cornices are twenty *Ignudi* (pp. 28, 34, 35, 42), true living statues, the spiritual brothers or lovers of the artist. Their features and forms combine feminine and masculine traits. They struggle with the earthly passions that have possessed them, torn between horror and fury, madness and suffering.

Then come the twelve *Prophets* and *Sybils* (pp. 26–27), figures less of knowledge than of doubt, "tragic torches of thought who burn and are consumed in the darkness of the pagan and Jewish worlds; the whole of human wisdom waiting for the Saviour's coming" (R. Rolland). Above the twelve windows, the Precursors and the Ancestors of Christ (pp. 24–25) seem filled with anxiety and fear. Finally, the four corners of the ceiling tell the sinister story of the "people of God": David cutting Goliath's throat, Judith carrying off the head of Holofernes, the Hebrews writhing as they are bitten by the snakes of *Moses*, and the crucifixion of Haman. Scene after scene illustrates the wild thoughts and murderous fanaticism of a people without God, possessed by terror, sadness and

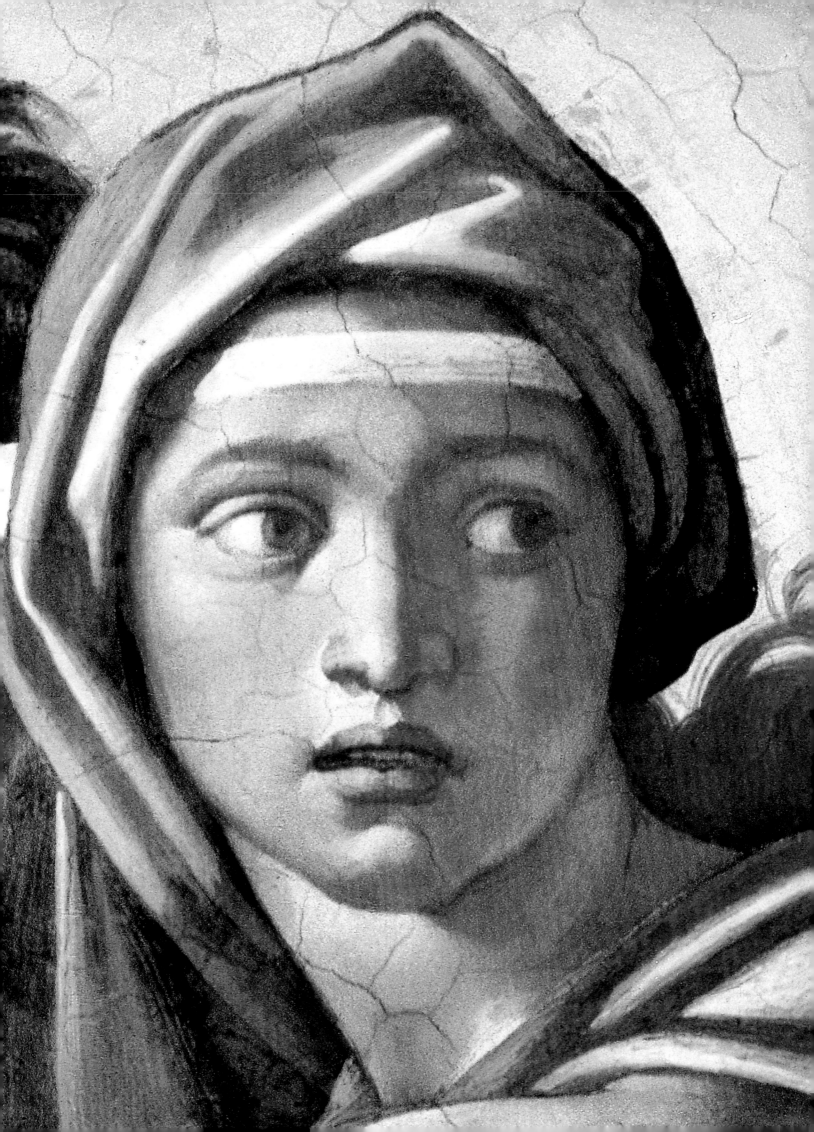

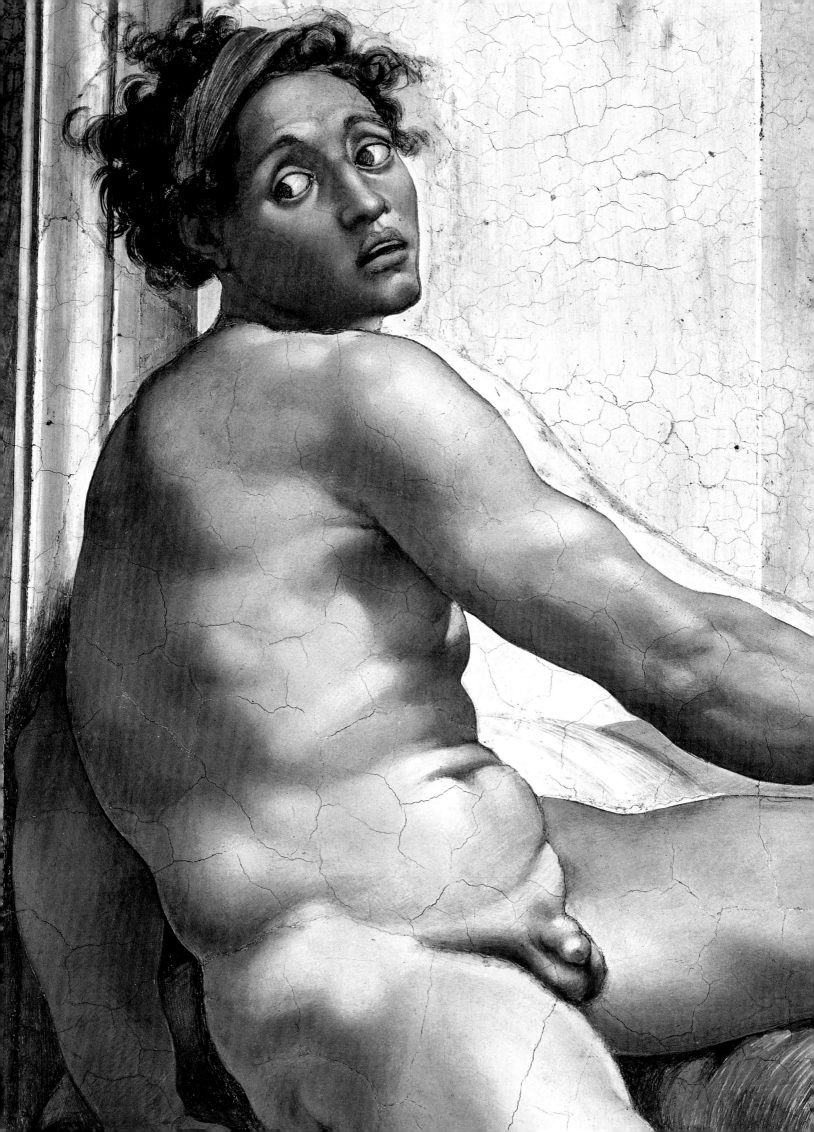

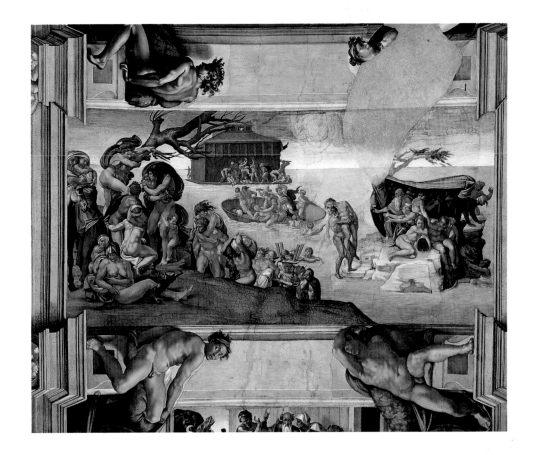

perpetual waiting. This point is clearer to us; we know that Michelangelo thirty years later completed the cycle with *The Last Judgement*; and that these figures await Christ and the Last Coming.

Many different and contradictory interpretations of this first cycle have been given. But whether this is history painting or its travesty, what matters is this: in these pictures, Michelangelo stands revealed to us, stripped naked, betrayed, just as he had feared. To his own irritation, the supremely indiscrete art of fresco painting had wrested from him his every secret.

If, for Michelangelo, sculpture was the supreme art, it was also the school at which painters should study and the ideal towards which their own art should tend. He had learned from Socrates that the object of painting was to represent the soul. What interested him in the men that he painted was their share of the eternal.

The changing shades of expression – the fleeting charms of life – he left to other artists, who devoted themselves to "a vacant and tiresome illusion". They laboured to create the merest phantoms. The objects they depicted were "dreams of the human imagination meant for waking men … images you might show from a distance to a young child who has not yet learned to reason, in order to deceive him". For Michelangelo, these phantoms of the senses seduced the soul away from the only real truth: the eternal Ideas.

The grand scale of his own paintings was inherent, for they were imitations of his sculpture. They reveal the man in his entirety, and through him, the "immortal ideas" so dear to his heart. The work is the man; in it we perceive the duality that was central to his character, the discrepant worlds that sought contradictory and simultaneous issue. Brute materialism confronts serene idealism. The intoxication of pagan beauty and strength confronts Christian mysticism. Physical violence infuses intellectual abstraction. The Platonic soul endues

Second bay of the vault,
The Flood, 1508–1509
Fresco, 280 x 570 cm
Sistine Chapel, Vatican

PAGE 28:
Ignudi, detail close to the *Flood,* above the *Sibyl of Eritrea,* 1509

At the junctions of the cornices are twenty ignudi. They are like living statues, the artist's lovers or soulmates, who share the earthly passions that torment him. These handsome young men are unrelated to the symbolic Biblical scenes that surround them. They are slightly older versions of the the *garzoni* who can be seen beside the Holy Family in the *Doni Tondo* (pp. 10–11), and seem to have been included for no other reason than their ambiguous beauty

PAGES 30 AND 31:
The Flood (detail)

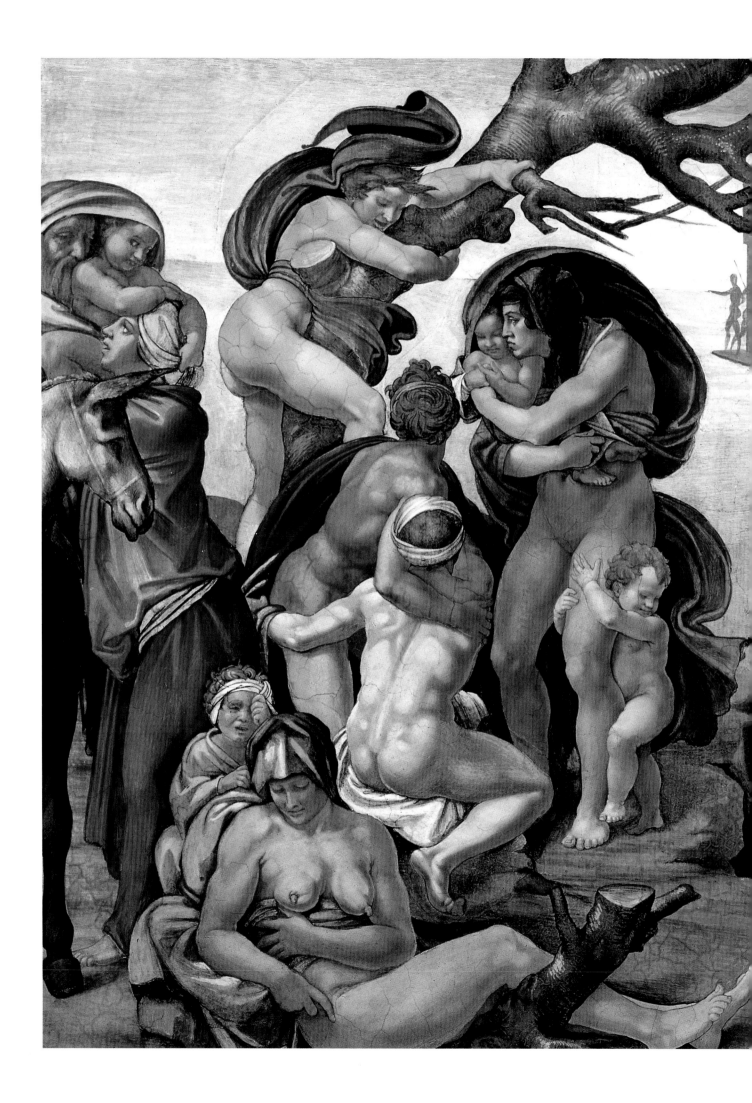

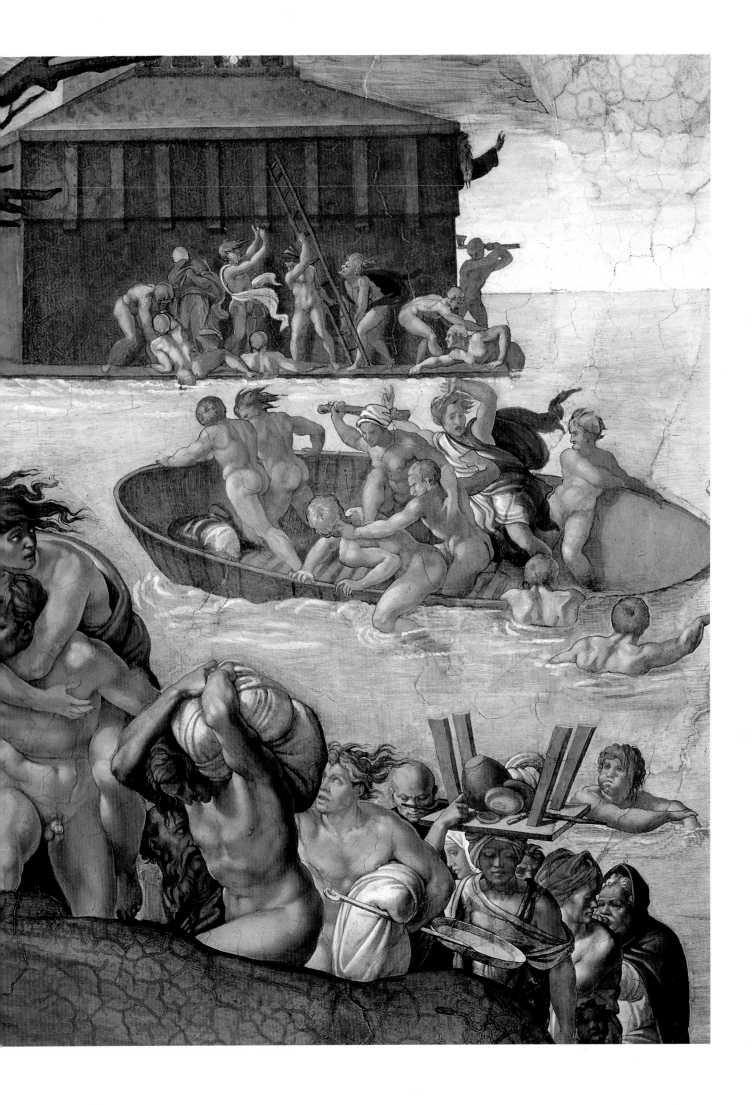

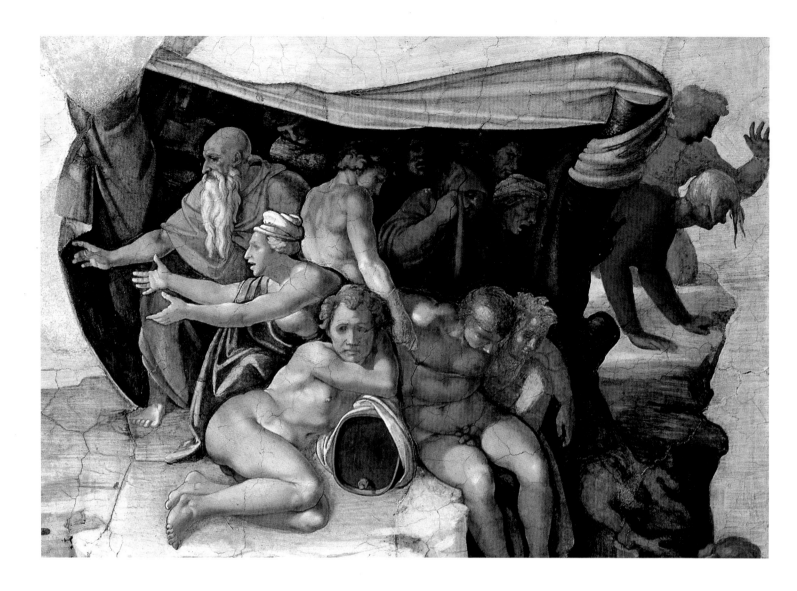

The Flood (detail)

It would seem that *The Flood* was the first scene to be painted, and was that which gave the artist the most difficulty. In particular, according to Condivi, Michelangelo had serious trouble with damp, and even thought at one point of giving up on the project, until the Pope sent the architect Giuliano da Sangallo to solve the problem for him.
As ever, Michelangelo prefered to focus on the terror and anguish of the characters, rather than simply illustrate the motif of the Ark. The dramatic intensity of the scene is heightened by the fact that we know its tragic conclusion: only Noah and his fellow passengers will be spared.

PAGE 33:
The Flood (detail)
This mother is a properly sculptural figure. Her wild heroism and Herculean force make of her a veritable Titan.

PAGES 34 AND 35:
Fourth bay of the vault, ***Original sin, Adam and Eve in Paradise***, 1509–1510
Fresco, 280 x 270 cm
Sistine Chapel, Vatican

athletic physique. This indissoluble union of opposing forces, the well-spring of his suffering, was also the source of his unique and universal genius.

What does the visitor to the Sistine Chapel feel on first seeing Michelangelo's extraordinary masterpiece? Something akin to the sentiment of Fabrice del Dongo, the hero of Stendhal's *The Charterhouse of Parma* (1839), on finding that he had stumbled onto the battlefield at Waterloo. There, all he saw was wisps of smoke and a few soldiers cutting each others' throats. He could not see "the battle", much less imagine it as a whole. In the same way, the visitor confronted with the seething mass of giant bodies that sprawls across the vaults and the walls of the chapel cannot immediately grasp the powerful unity by which they are bound together. Romain Rolland, who understood Michelangelo as intimately as he did that other disproportionate genius, Beethoven, described his impressions thus:

"It is dangerous to try to describe this work. Many have failed in this impossible task. Analyses and commentaries proliferate; they have killed the work by tearing it into pieces. You must stand in front of it and immerse yourself in the abyss of this delirious soul. It is a work of terror; those who scan it in cold blood cannot hope to comprehend it. It is love or hate at first sight. This work suffocates and sears. There is no landscape, no nature, no air, no tenderness, and almost nothing human; nothing but primitive symbolism and decadent knowledge, an architecture of naked contorted bodies. The ideas that drive the work are arid,

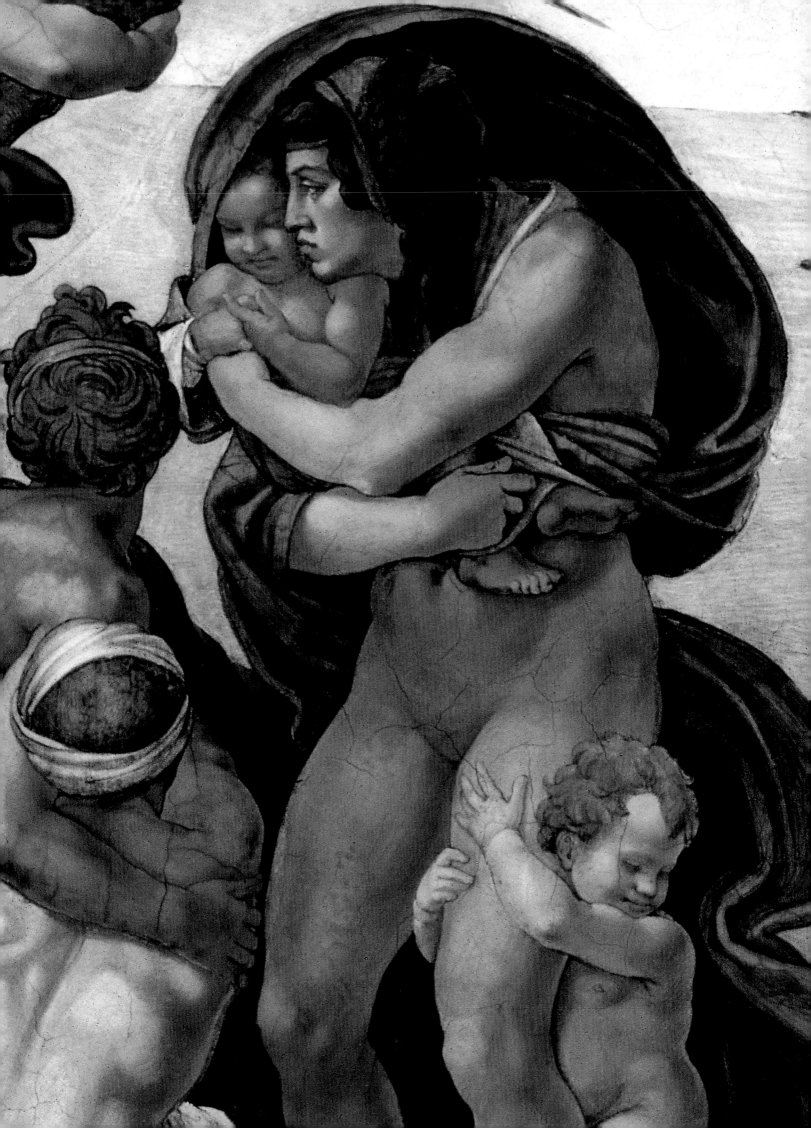

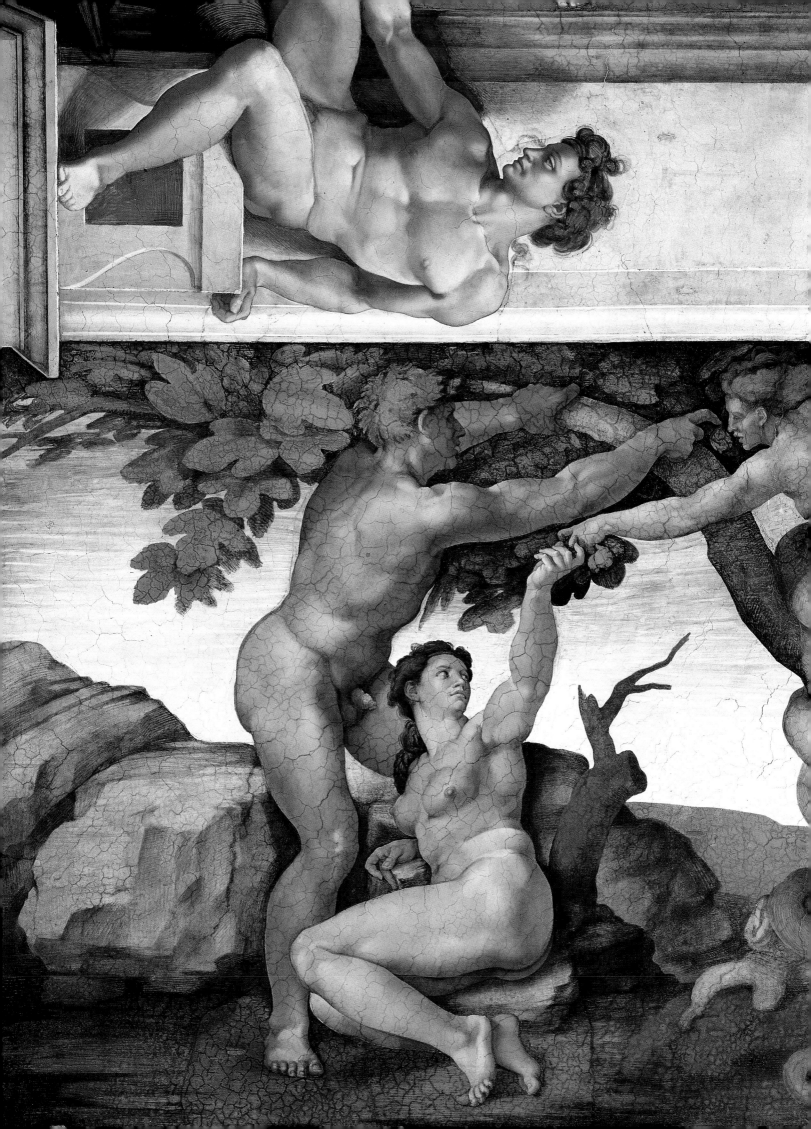

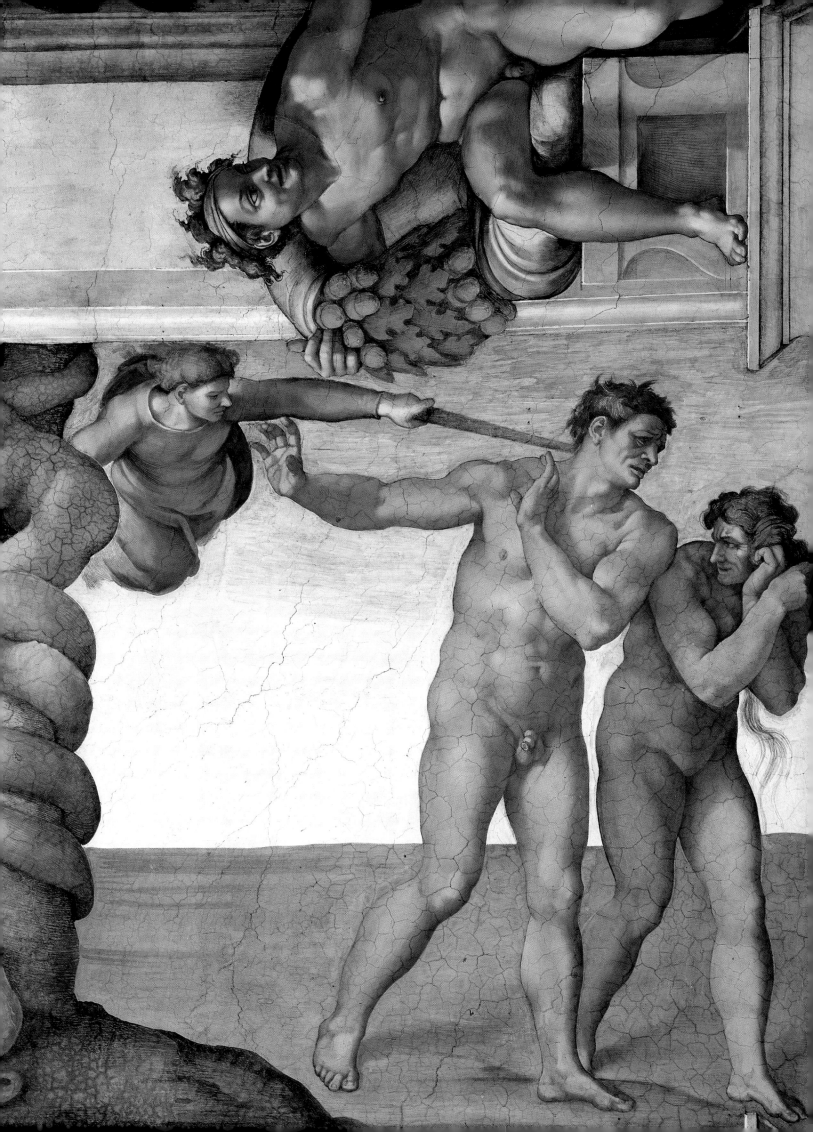

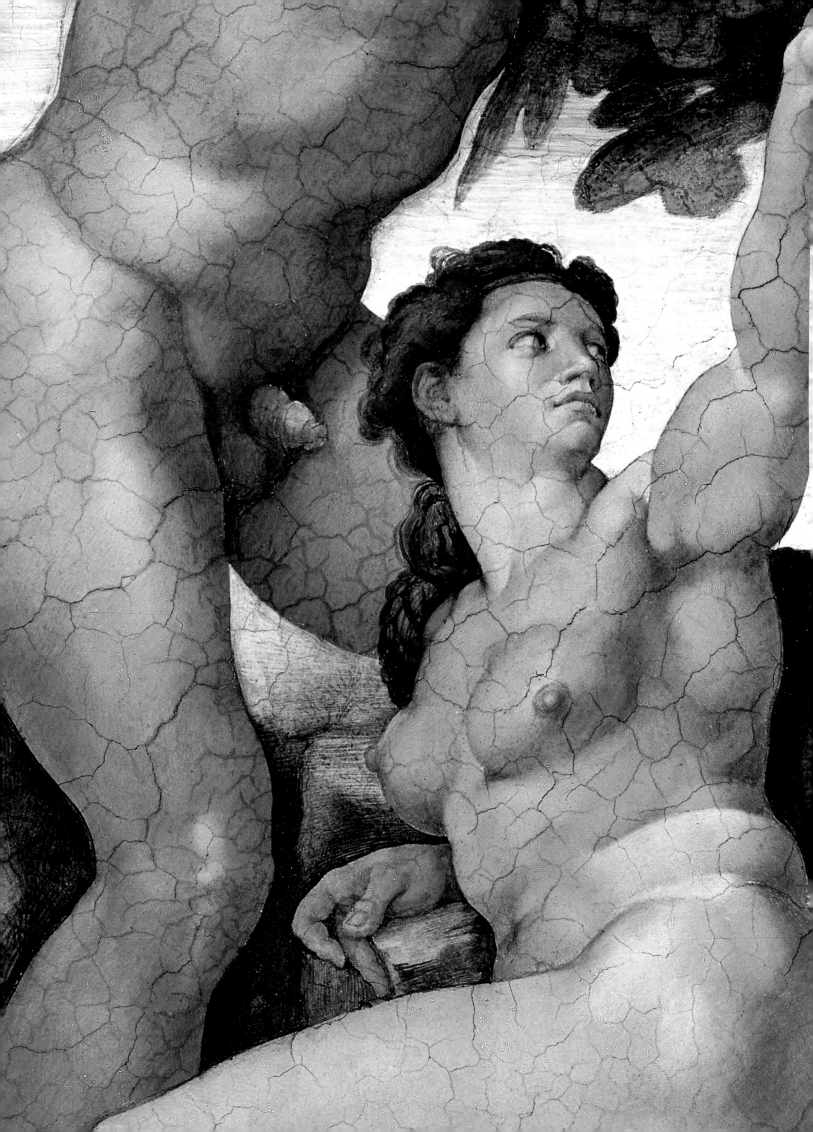

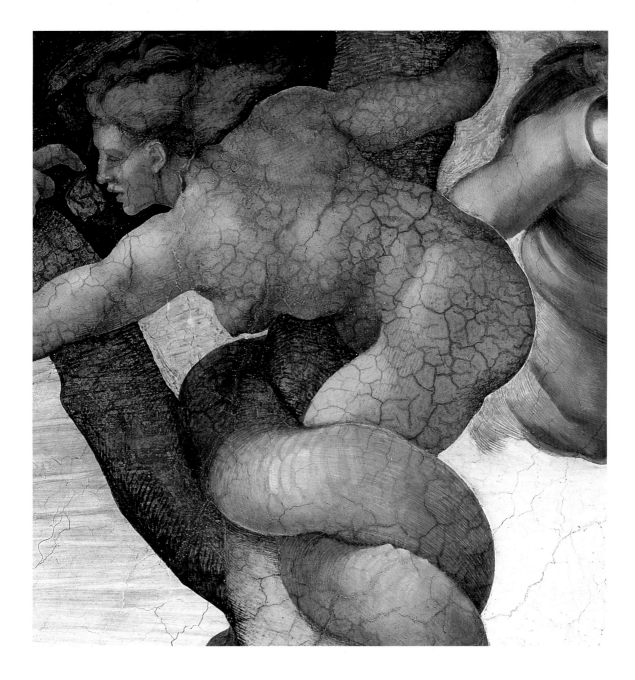

untamed and all-devouring, like the south wind blowing through the desert. There is no shadow anywhere, no spring where one might slake one's thirst. A whirlwind of fire, the grandiose, vertiginous hallucination of a mind whose only goal is to lose itself in God. Everything calls on God, everything fears him, everything shouts his name. There is a hurricane blowing through this tribe of giants: the whirlwind of God spinning in the air as he creates the sun, like a massy projectile launched into space. The deafening roar of the storm is all around you. There is no escape. Either you hate the violence done you by this brutal power, or you give yourself up to it unresisting, like the souls of Dante swept up in the eternal cyclone. When you realise that this hell was, for four years, the very soul of Michelangelo himself, then you understand (as we shall see below) why he was so badly burned by it, for so long, so that life itself seemed dried up in him, like overtaxed land that can no longer bear fruit.

"These heroic bodies cover every surface with their tumultuous swarm, their force and unity evoking both the monstruous dreams of the Hindu imagination and the imperious logic and iron will of ancient Rome. The images unfolding across this vault and these walls are the flowering of a pure, wild beauty.

ABOVE:
Original sin (detail)
According to Michelangelo, the snake that tempted Eve was itself female – whence the breast with which he has endowed it here.

PAGE 36:
Original sin (detail)
The juxtaposition of a supposedly female face and masculine genitalia is a common feature of Michelangelo's work. We have already met it in the *Tondo Doni* (pp. 10–11), and we will see it again in the detail of Catherine of Alexandria kneeling and turning her face towards St Blasius in the *Last Judgement* – an "immodest gesture" which caused uproar at the inauguration of the painting (p. 73).

Study for **The Creation of Adam,** ca. 1510
Red chalk, 19.3 x 25.9 cm
The British Museum, London

PAGE 39:
Study for **The figure of Adam,** 1511
Red chalk, 25.3 x 119.9 cm
Teylers Museum, Haarlem

PAGES 40 AND 41:
Sixth bay of the vault, **The Creation
of Adam,** 1510–1511
Fresco, 280 x 570 cm
Certainly the most famous image in the
Sistine Chapel.

PAGE 42:
One of the four *ignudi* who surround the
prophet Jeremiah.
Michelangelo, taking his cue from the acorns
in Julius II's coat of arms, has placed a fine
bunch of large acorns next to the prophet.

PAGE 43:
Study for the **Libyan Sybil,** 1511
Chalk on paper, 29 x 21 cm
The Metropolitan Museum of Art, New York

Nowhere has its like been seen. It is at once bestial and divine. It combines a scent of Hellenic elegance and nobility with the fetor of primitive humanity. These giants, with their Olympian chests, their enormous loins and flanks "in which", said the sculptor Guillaume, "you feel the sullen weight of their entrails", have barely emerged from their double origin in the animal and the divine."

From this titanic struggle, Michelangelo had emerged victorious, much to the chagrin of his enemies. But what a price in suffering he had paid. Often he thought of giving it all up and again taking flight. In the midst of his work on *The Flood,* mould began to cover the fresco, altering forms and colours as it spread. Michelangelo despaired; he wanted to abandon the project. But the Pope sent him the architect Giuliano da Sangallo who eliminated the mould by reducing the water content of the lime.

Fresco is a very delicate operation, which requires great technical expertise. Vasari cites one example:"the whole area that has been prepared must be executed in the space of a single day... the painting is done directly onto the still wet lime, without a pause, until the area prepared for that day has been finished ... the colours imprinted on the damp surface produce an effect which changes as the wall dries". Unlike other techniques, such as oil or distemper, fresco painting can only be retouched once it has dried; "what has been worked *al fresco* will remain, and what has been retouched when dry can be removed with a wet sponge".

The relationship between Pope and painter was turbulent. "One day", Condivi tells us, "the Pope having asked him when he would finish the work, Michelangelo replied, as usual: 'When I can!' The Pope was in an irritable frame of mind and struck him with his stick, repeating after him: 'When I can!

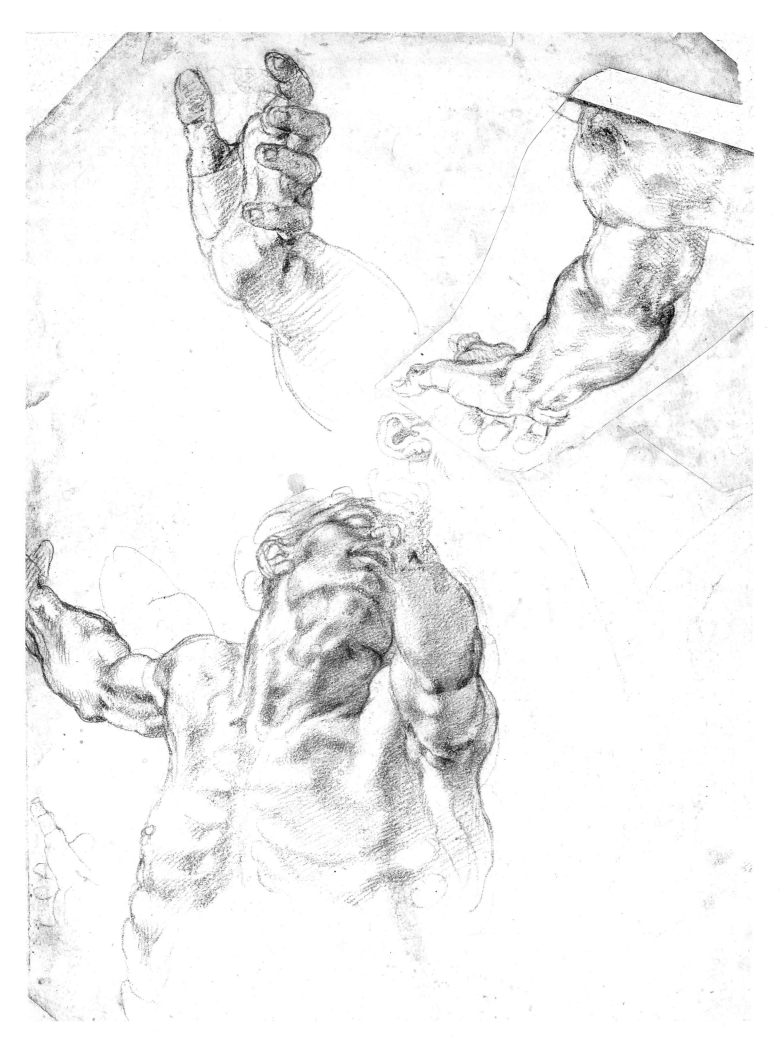

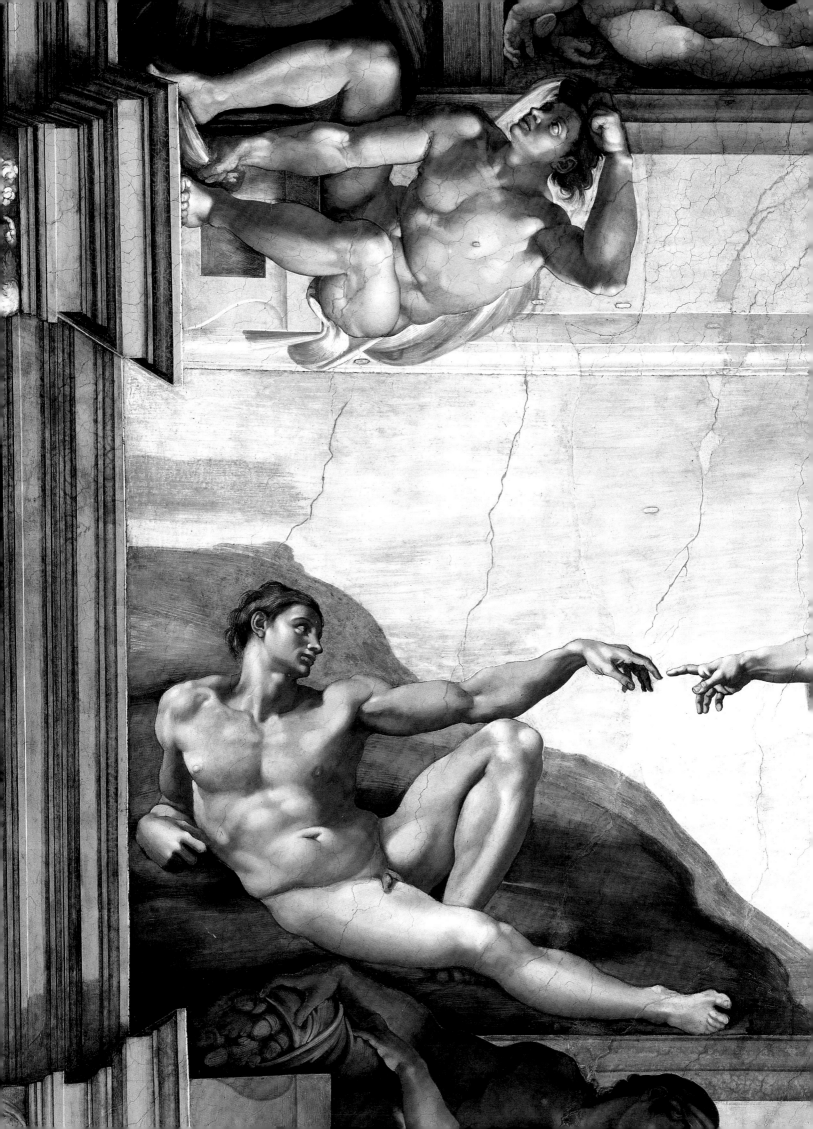

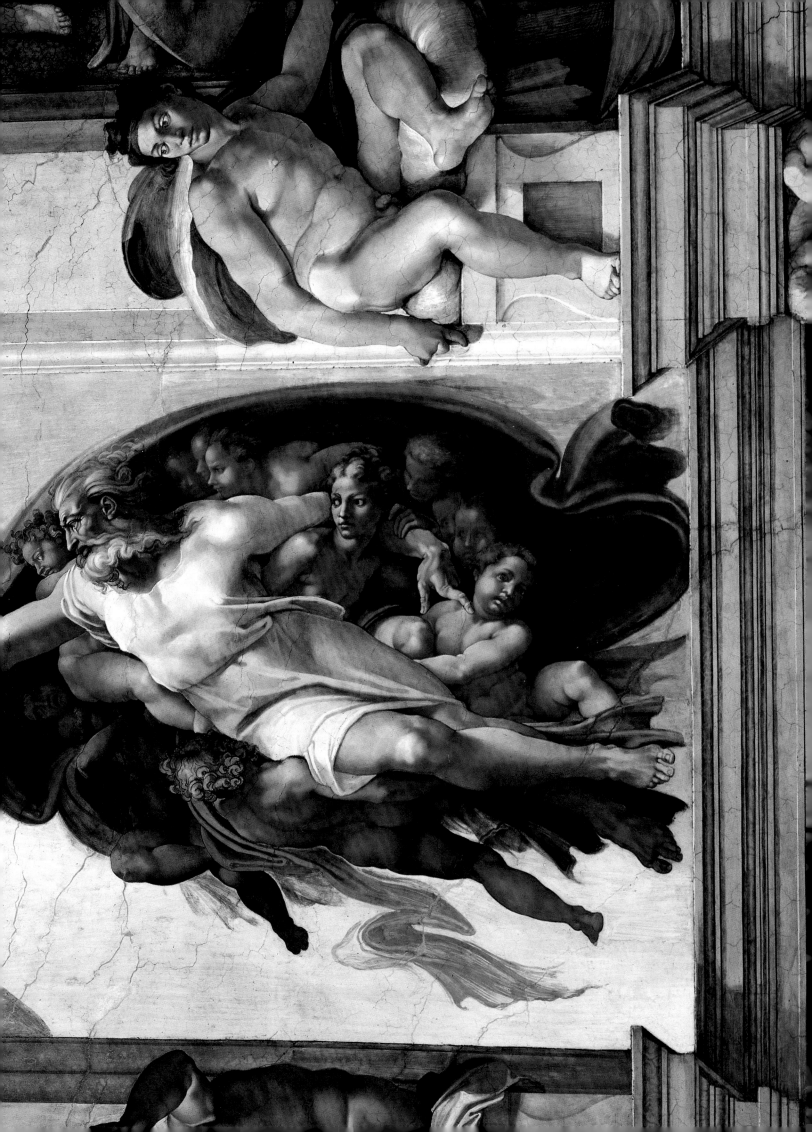

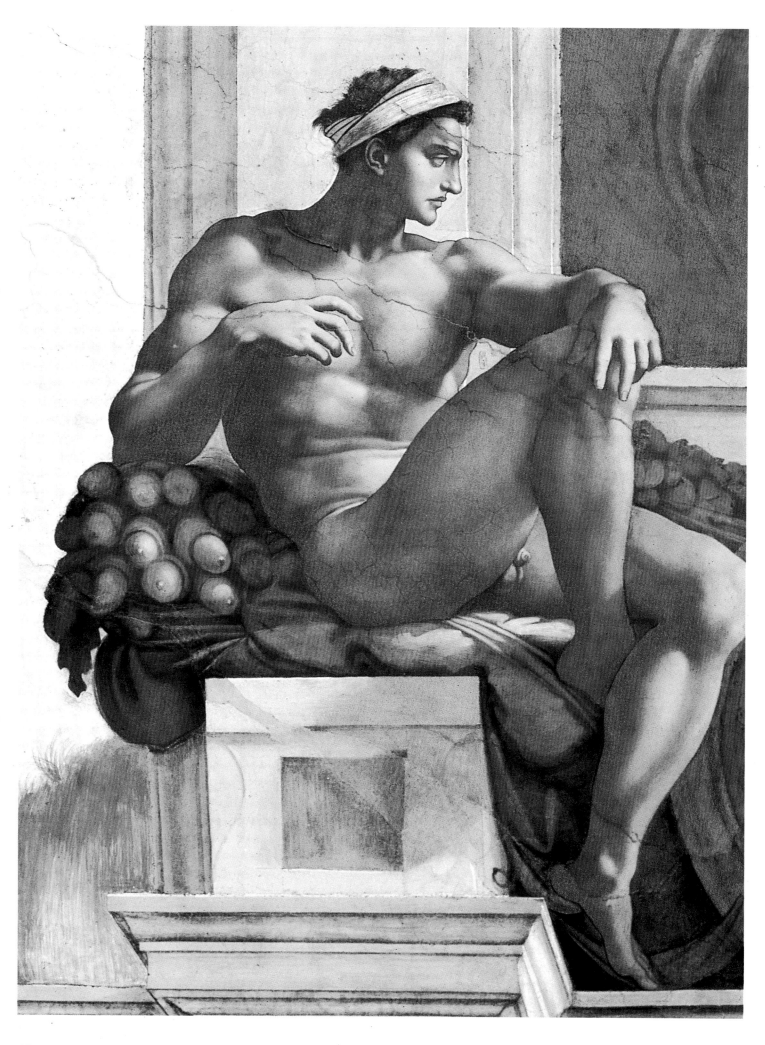

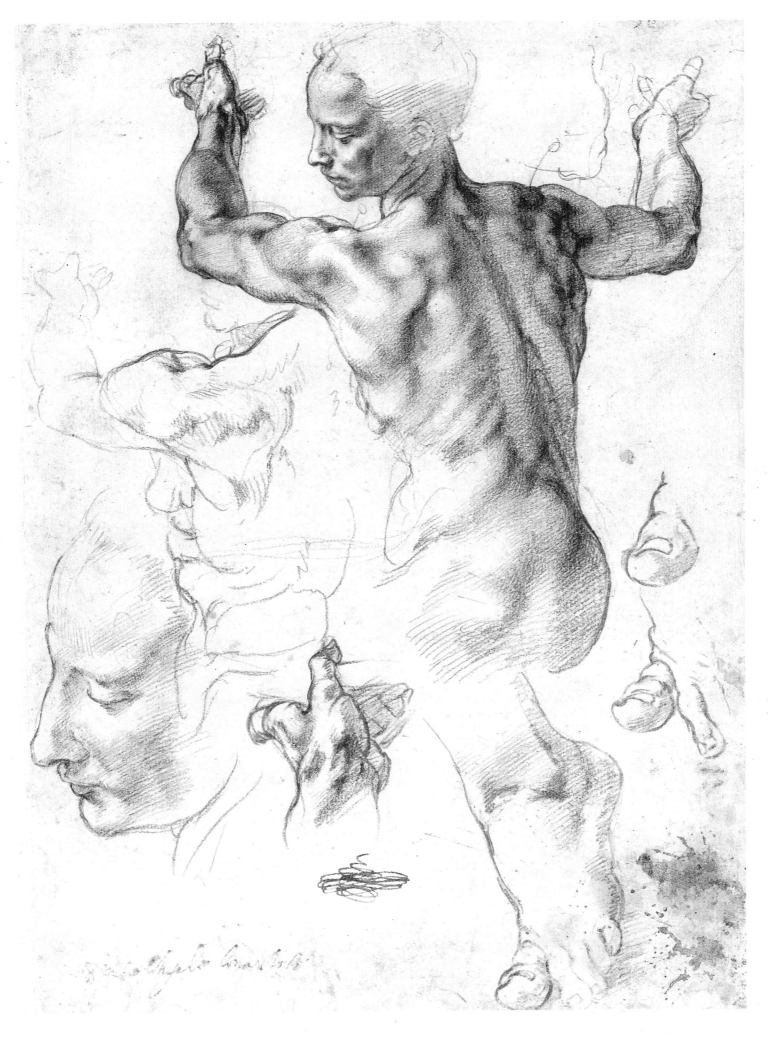

43

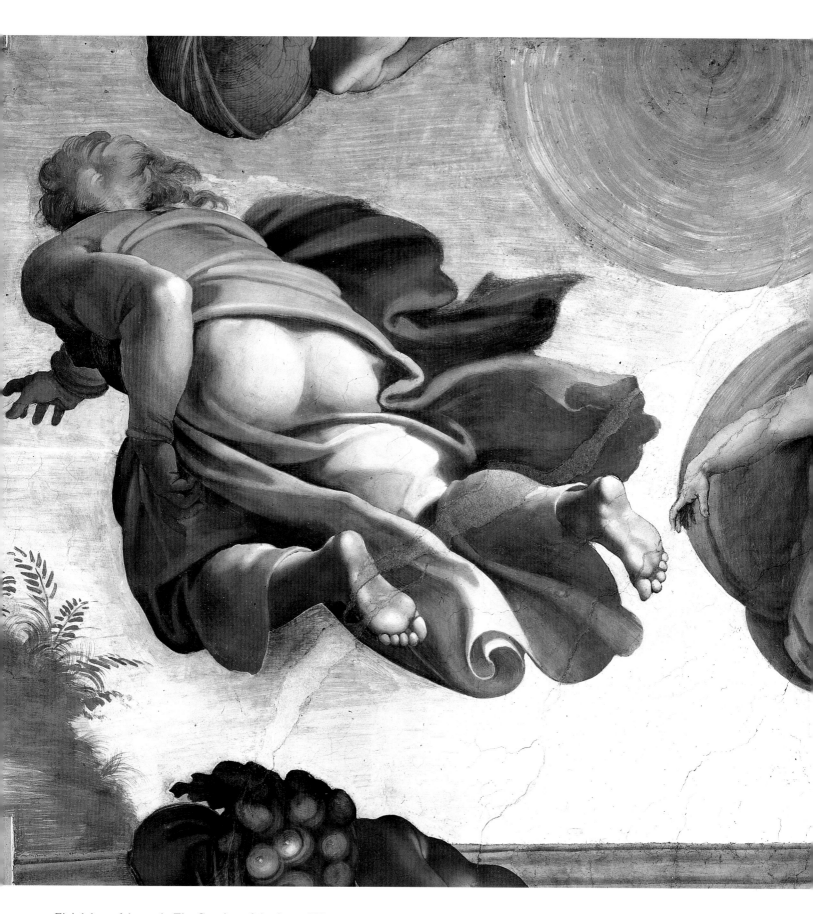

Eighth bay of the vault: The Creation of the Stars, 1511
Fresco, 280 x 570 cm
This section shows the creation of the sun – and the moon.

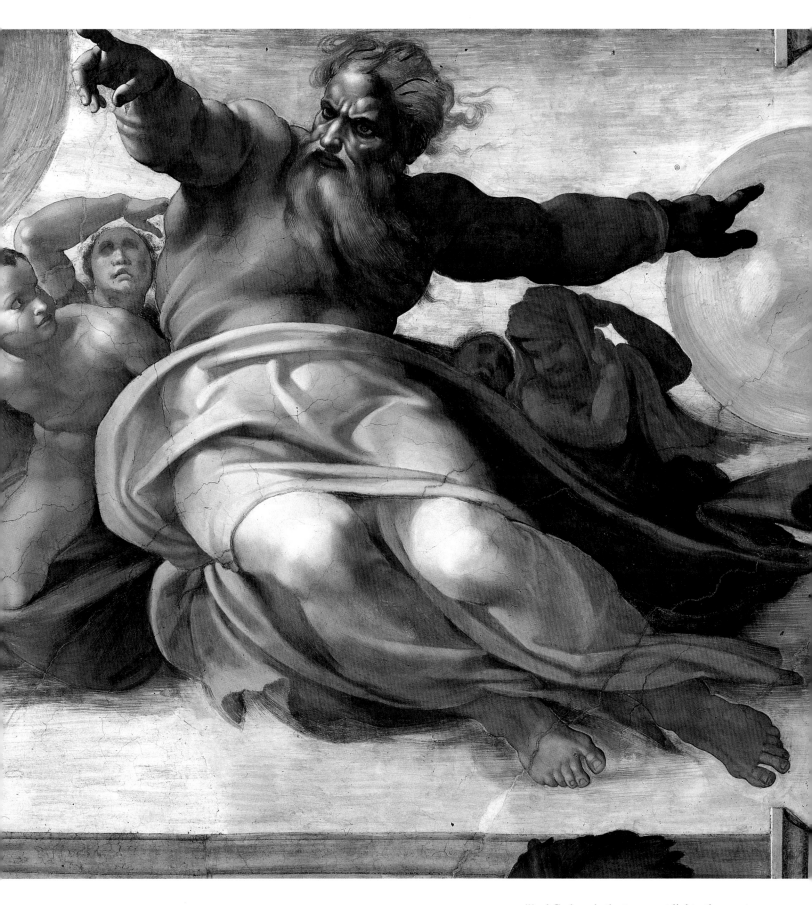

"And God made the two great lights, the greater light to rule the day, and the lesser light to rule the night: he made the stars also." (Genesis, 1, 16).

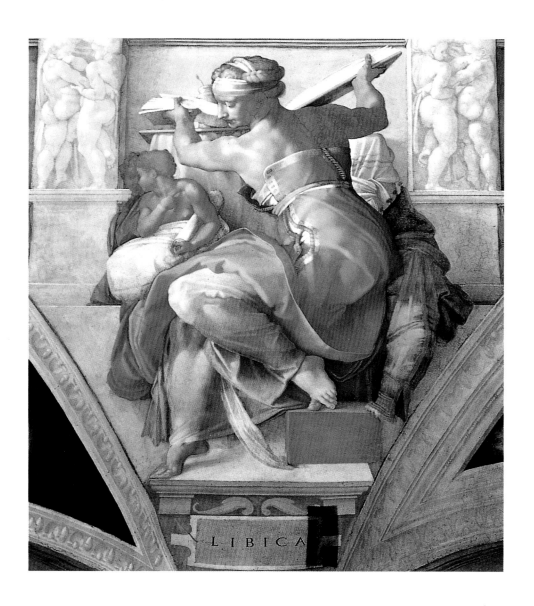

LIBICA

Ninth bay of the vault, 1511
Two medallions continuing *The Separation of the light and the darkness*

The Libyan Sibyl
(395 x 380 cm) who is closing and replacing the great book of time.

The Prophet Jeremiah
(390 x 380 cm) who is announcing the new covenant that the Lord intends to make with his people.
These two scenes look forward to *The Last Judgement.* The figure of Jeremiah, who is lost in anguished meditation, has often been interpreted as an imaginary self-portrait of the artist, his thoughts oppressed by his vision of the "second death" and the weight of his sins.

When I can!' Michelangelo ran back to his house and made ready to quit Rome immediately. Fortunately, the Pope quickly sent Accursio, a very amiable young man, to take 500 ducats to the painter. Accursio calmed him down as best he could, and apologized for Julius II. Michelangelo accepted his apologies".

But the fresco was still not finished, and the Pope, growing ever more impatient, finally threatened to have the painter thrown off the top of his scaffolding. Michelangelo was obliged to unveil his masterpiece. "That was why", he said later, "this work was not as complete as I should have liked; the Pope's haste prevented my finishing it".

On 1 August 1511, Julius II said mass in the Sistine Chapel, *ut picturas novas ibidem noviter detectas videret.* The work was finally completed in October 1512. On 31 October of that year, the chapel was opened to the public. Four months later, Julius II was dead. He was granted only a few months to contemplate the masterpiece he had commissioned. The man who punished Michelangelo for his flight by forcing him to paint rather than sculpt was thus punished in his turn.

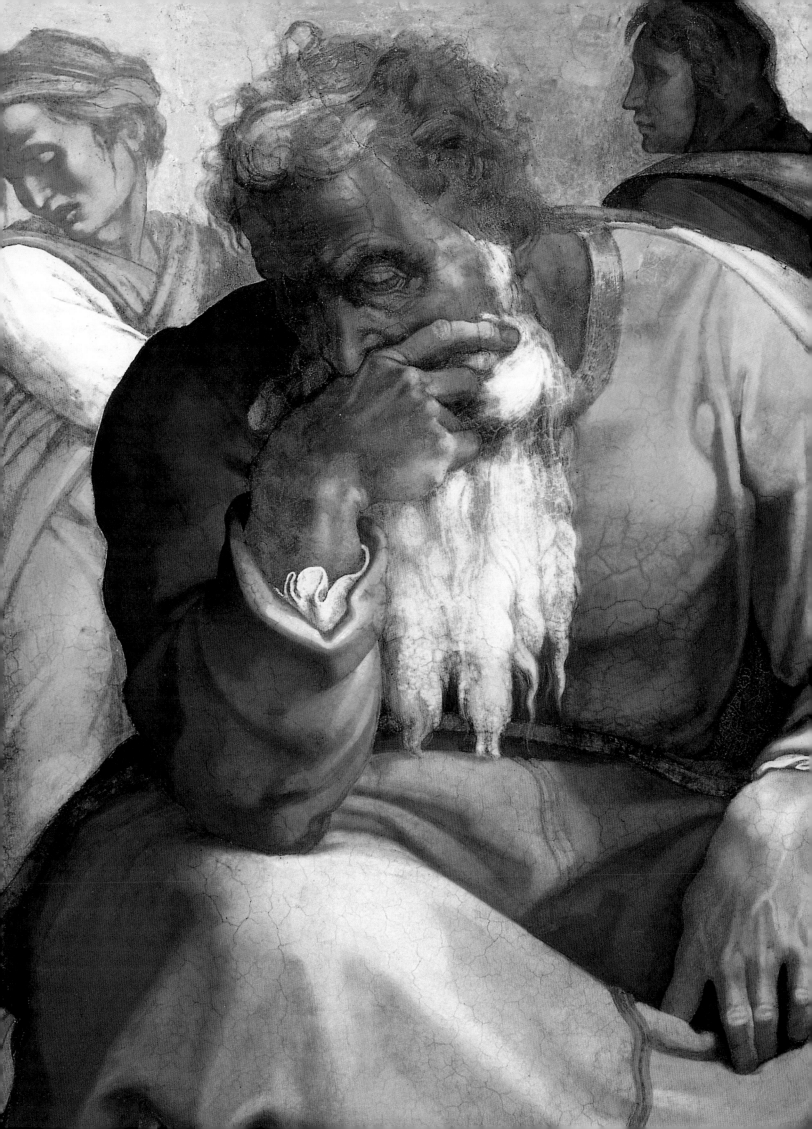

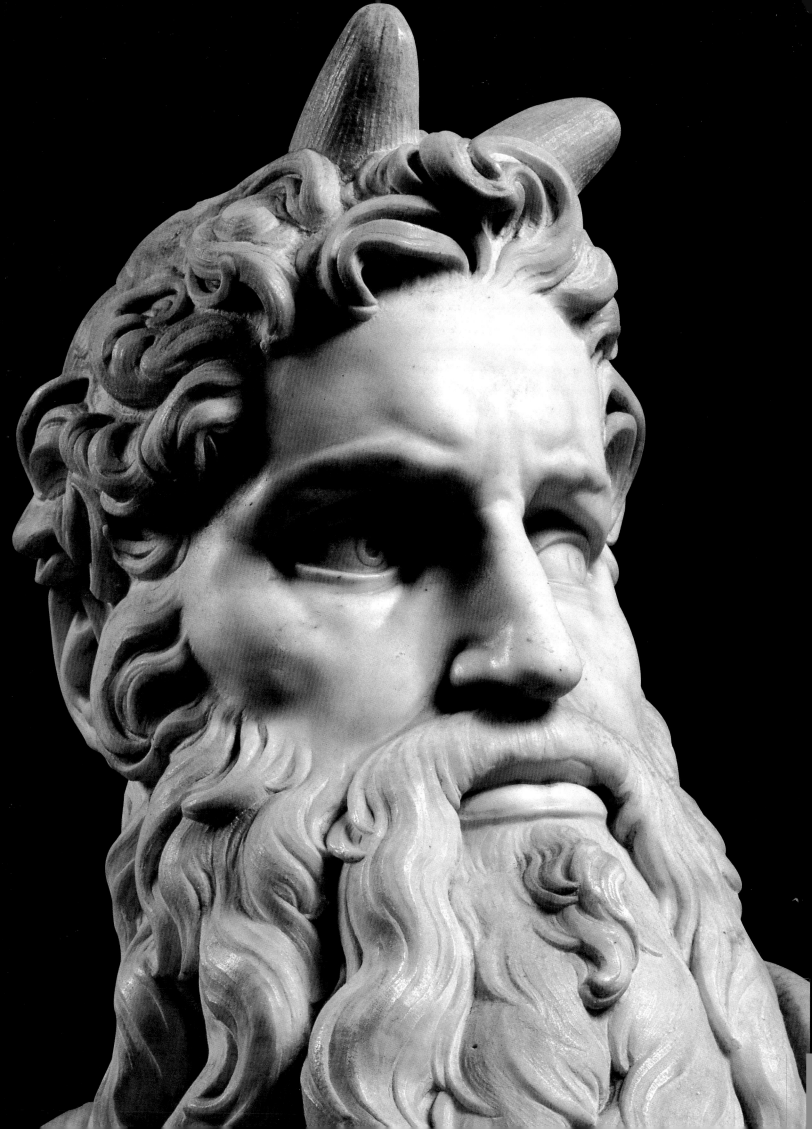

Dreams of a Titan 1513–1534

The suffering of the four years he had spent perched on the scaffolding in the Sistine Chapel began to fade into memory, and "his agitation slowly subsided, like a raging sea that returns to its bed" (R. Rolland). His fresco had proved a triumph, but Michelangelo was still anxious to return to sculpture - in particular, to the project closest to his heart: the tomb of Julius II (p. 50). As Condivi puts it: "Michelangelo again embarked upon the tragedy of the tomb". This "tragedy" lasted forty years in all, from 1505, when the first project was drawn up, until 1545, when the sixth design was finally built. Michelangelo's projects were hyperbolic, but the continued delays cannot all be laid at his door. Pope followed Pope, and each had his own ideas.

Julius II, ever the realist, had stipulated in his will that the tomb should be built on a less imposing scale. His executors seem to have ignored this request. Michelangelo, meanwhile, worked on the project in solitude, emerging with a plan more grandiose than ever. The new pope, Leo X (Giovanni, son of Lorenzo de' Medici), encouraged him. Michelangelo was delighted by the favourable reception of his ideas. He later wrote: "On the death of Pope Julius, at the outset of Leo's reign, the Aginensis [the Cardinal of Agen, executor of Julius's will] decided to enlarge the monument, making the work still greater than my first design; a contract was signed". He agreed to finish the work within seven years, and to undertake no other major works for the duration. In return, he would be paid 16,500 ducats, of which 3,500 were to be retained, having been paid him while Julius II was still alive. The new project comprised 32 large statues illustrating the triumph of the Church over the pagan world. In the lower register would be the *Victories*, representing "the provinces conquered by this pontiff [Julius II] and brought under the apostolic Church" (Vasari), and the *Slaves*, symbolising pagan peoples acknowledging the true faith. Above these would be *Moses* and *Saint Paul*, representing the victory of mind over body. The contract specified that the monument (p. 50 top right) would be placed against the wall of the church: "On each of the three sides, there will be two tabernacles, each containing a group of two figures; on each of the pilasters that flank the tabernacles, there will be a statue. Between the tabernacles, bronze reliefs. On the platform, above the base, the figure of the Pope held by four figures on pedestals. Finally, the topmost register of the tomb will be thirty five palms high, and crowned with five colossal statues". The tomb built in 1545 was, then, the merest shadow of this original project. Between 1516 and 1534, much of Michelangelo's energy was spent devising gigantic projects that never saw the light of day.

This study for the head of Leda is the only trace that survives of a painting of Leda and the swan, ca. 1530
Red chalk, 33.5 x 26.9 cm
Casa Buonarroti, Florence
The woman's face would seem to be, in fact, that of a *garzone*. A doublet can just be made out at the base of the neck.

ABOVE:
Study for the prophet Jonah, ca. 1512, who figures at the end of the tenth bay. It too has been compared to the face of the Virgin in the *Doni Tondo* (pp. 10–11). Michelangelo was quite happy to transform the sex of a figure, reproducing it in the same pose now as a man, now as a woman.

PAGE 48:
Detail of the *Moses* for the Tomb of Julius II, ca. 1515–1516
San Pietro in Vincoli, Rome

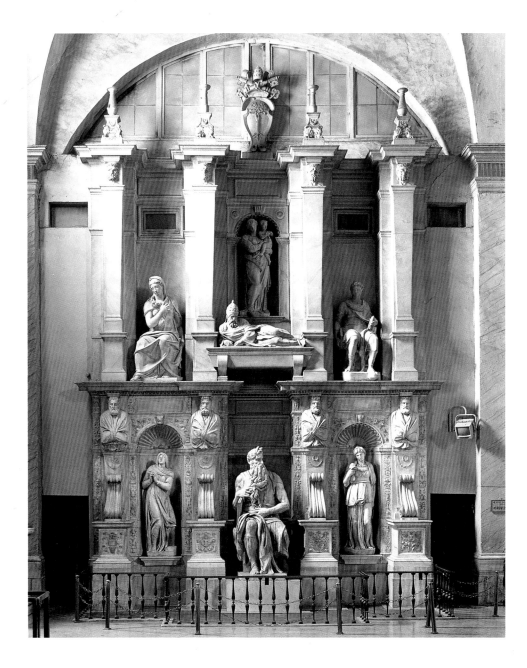

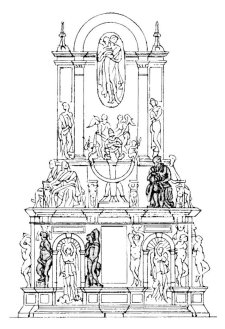

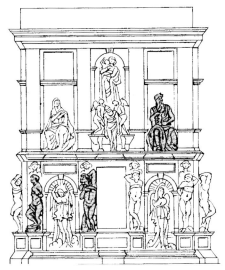

For three years, however, he worked almost exclusively on this monument, which was the inspiration for many of his finest works. His *Moses* (pp. 48, 51) is a summary of the entire monument. It was intended for one of the six colossal figures that crowned the tomb. Today, it constitutes the main attraction of San Pietro in Vincoli in Rome. Elder brother to the Sistine Prophets, the Moses is also an image of Michelangelo's own aspirations, a figure, in de Tolnay's words, "trembling with indignation, having mastered the explosion of his wrath". The premise of the monument had been a cold, abstract, self-serving allegory: its statues were to symbolise how "since the Pope's death, the Virtues have been taken prisoner by Death". Michelangelo stripped the project of these shallow lies and turned it into a cry of anger and revolt against the abjection of this world and the oppression of human life. Vasari declared with admiration: "So well did he render in marble the divine character that God had imprinted on this most holy face; in addition to the deeply-etched lines and the superb curves formed by their edges, the muscles of the arms, the bones and nerves of the hands are beautifully and perfectly executed, and the legs, knees and feet are treated as they should be, as are the sandals".

The successive projects for the *Tomb of Julius II*, reconstructed by Charles de Tolnay:
Left, what remains of the project: Moses, below, remains as a summary of the entire monument. He is also the divine mirror of the artist's soul.
Above, top, the ambitious project of 1513. Beneath it, the 1516 project, already reduced in scope, with Moses on the first tier.

PAGE 51:
Moses, detail of the Tomb of Julius II, 1513–1515, reworked in 1542
Marble, height 235 cm
San Pietro in Vincoli, Rome

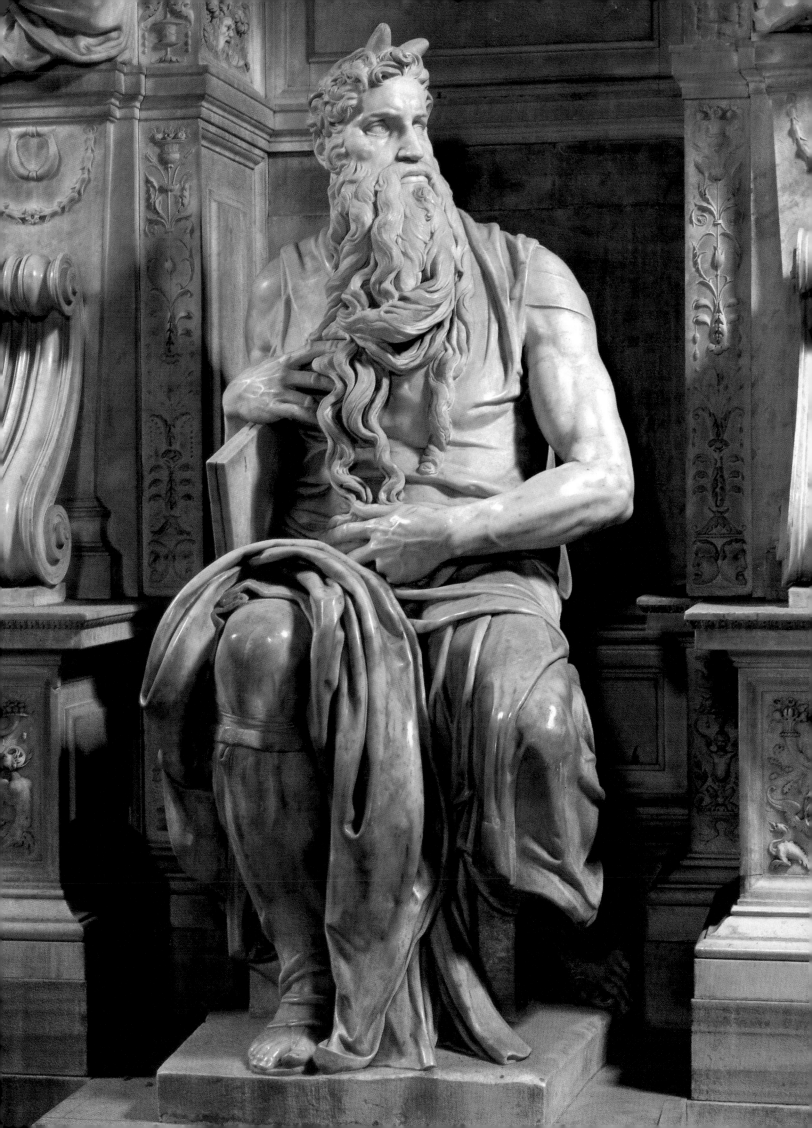

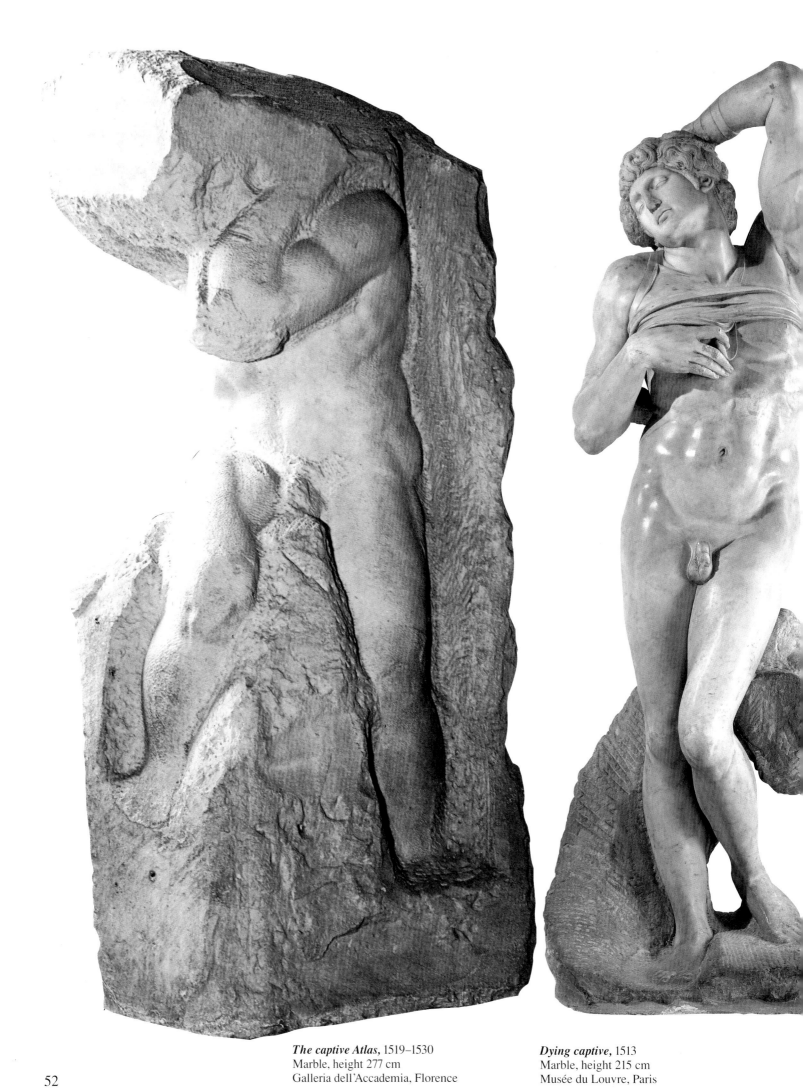

The captive Atlas, 1519–1530
Marble, height 277 cm
Galleria dell'Accademia, Florence

Dying captive, 1513
Marble, height 215 cm
Musée du Louvre, Paris

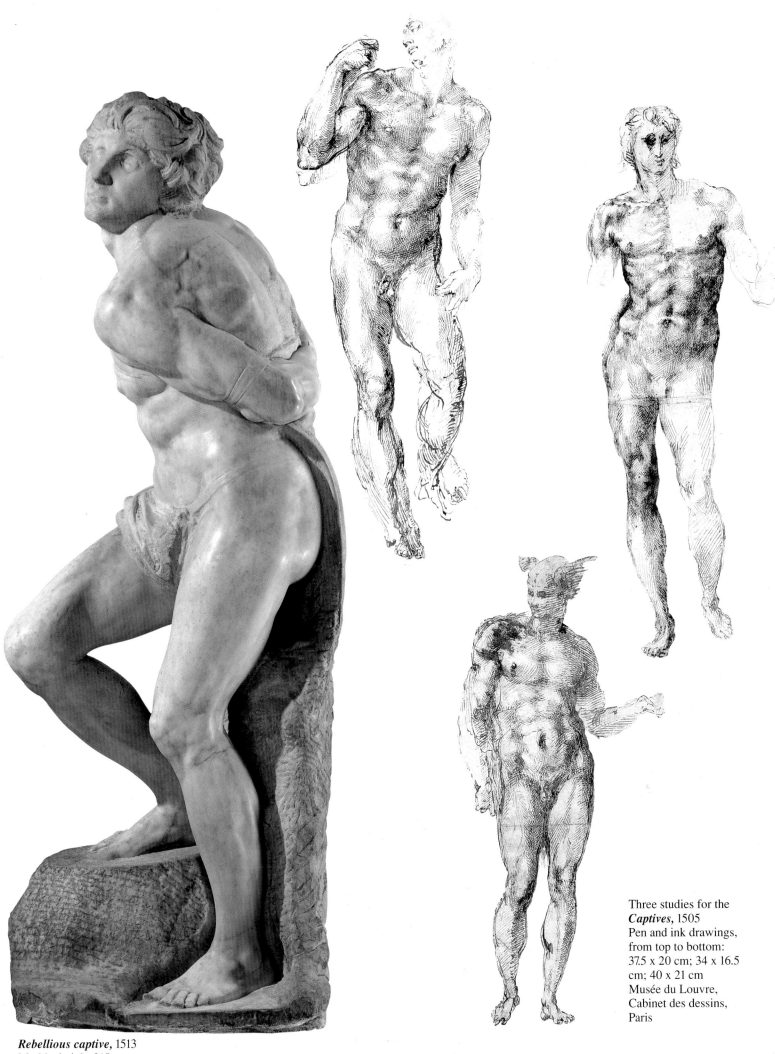

Rebellious captive, 1513
Marble, height 215 cm
Musée du Louvre, Paris

Three studies for the
Captives, 1505
Pen and ink drawings,
from top to bottom:
37.5 x 20 cm; 34 x 16.5
cm; 40 x 21 cm
Musée du Louvre,
Cabinet des dessins,
Paris

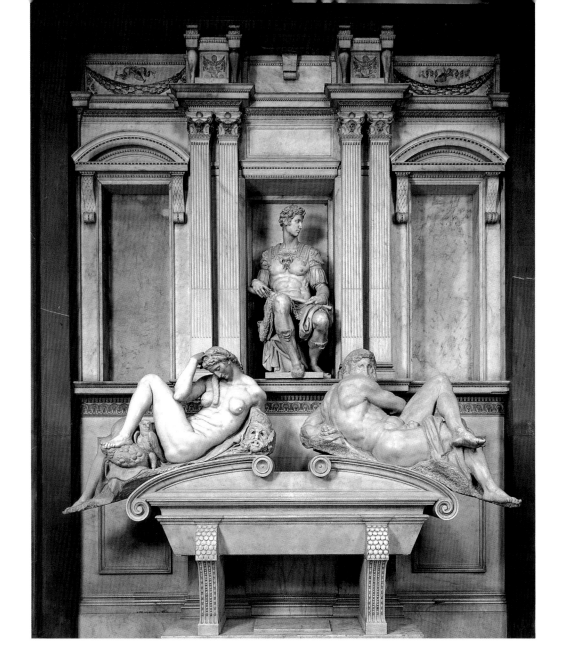

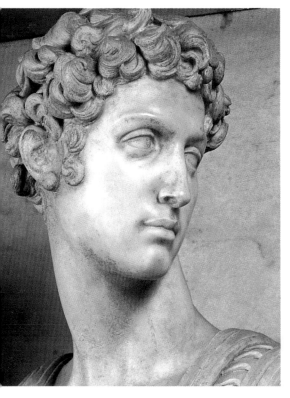

Two other masterpieces came out of this project, the *Dying Slave* (p. 52) and the *Rebellious Slave* (p. 53), which were to have decorated the pilasters of the lower register. They were originally intended to represent pagan peoples acknowledging the true faith, but de Tolnay suggests that here too Michelangelo went far beyond his premise, transforming them "from trophies into symbols of the bitter, hopeless struggle that pits the human soul against the chains of the flesh". Whatever the subject, Michelangelo could never avoid returning to his one essential subject: himself.

Not even a Medici Pope is immune to jealousy, especially when succeeding to another Medici. For the first three years of his reign, Leo X gave no sign of opposition to his predecessor's glorification, and Michelangelo pursued his dream unhindered. In 1515, however, the new Pope sought to tear his sculptor away from his monumental task and employ him in a project of his own. He began by flattering Michelangelo's aristocratic pride, appointing his brother *comes palatinus*, and granting the Buonarroti family the right to include the Medici *palla* in their coat of arms, with three lilies and the monogram of the Pope. And he offered Michelangelo the one inducement he knew to be irresistible: a new project, inviting him to design the façade of San Lorenzo, the Medici church in Florence. Convinced he could undertake both projects at once, Michelangelo

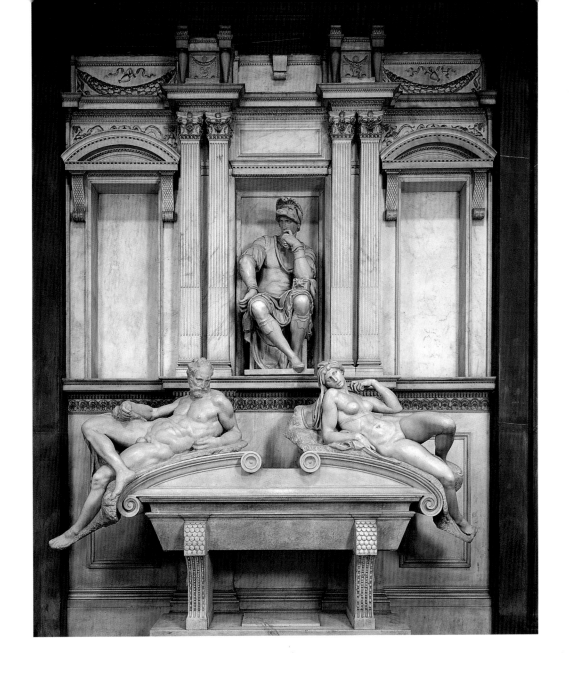

eagerly started work on the new commission, and forwarded a drawing of the façade (p. 59). His fervour found expression in a letter to Domenico Buonin-segui in July 1517: "I intend to make of this façade of San Lorenzo... a mirror for architecture and sculpture for all Italy... I will complete the work in six years. Messer Domenico, give me a definite answer as to the Pope and the cardinal's intentions: this would give me the utmost joy". The contract was signed on 19 January 1518. The time allotted for the work was eight years.

The heirs of Julius II then counter-attacked, by offering Michelangelo a new, less rigorous contract. This he immediately signed, insensible of any contradiction between the demands of the two projects. The papal monument was now reduced to half its original size, there were to be only 20 statues, not 32, and he had nine years to complete the work.

According to Michelangelo, Leo X then forbade him to work on the tomb of Julius II: "Pope Leo", he wrote, "did not want me to make a monument to Julius". Things again turned sour. No progress was made, and on 12 March 1520, a brief from Leo released Michelangelo from the San Lorenzo contract. This time, Michelangelo himself was to blame. Greedy for projects and fickle in his attentions, he had neither built the San Lorenzo façade nor completed the papal tomb.

Tomb of Lorenzo de' Medici, 1524–1531
Marble, 630 x 420 cm
New Sacristy, San Lorenzo, Florence

PAGE 54 ABOVE:
Tomb of Giuliano de' Medici, 1526–1531
Marble, 630 x 420 cm
New Sacristy, San Lorenzo, Florence

PAGE 54 BELOW:
Giuliano de' Medici, detail of the head,
1526–1533
Marble, height of the whole statue 173 cm

PAGE 57:
Dawn, detail of the Tomb of Lorenzo
de' Medici, 1524–1531
Marble, length 203 cm

Studies of grotesque heads, 1530
Red chalk, 25.5 x 35 cm
The British Museum, London

Wall decoration
New Sacristy, San Lorenzo, Florence

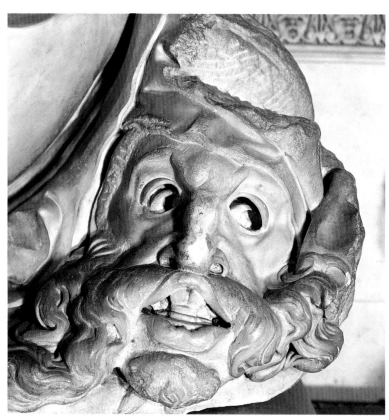

Mask of **_The Night,_** detail of the Tomb of
Giuliano de' Medici, 1526–1533
Marble
New Sacristy, San Lorenzo, Florence

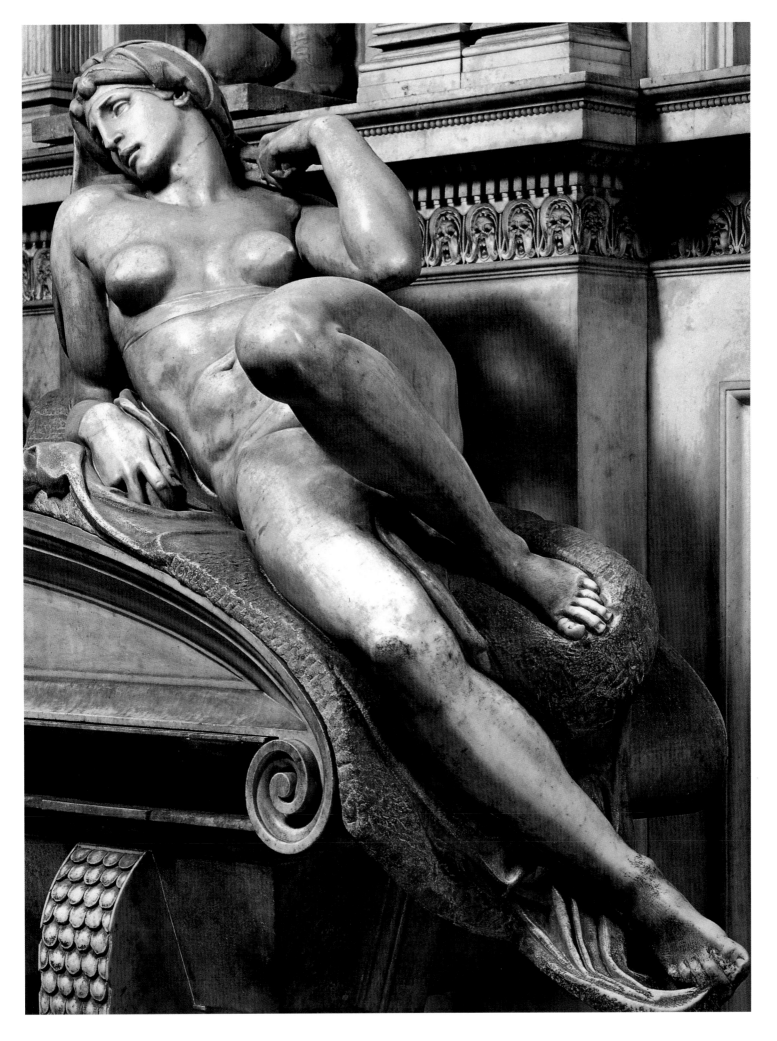

Project for the Medici Tombs, 1516–1532
Black chalk, 26.4 x 18.8 cm
The British Museum, London

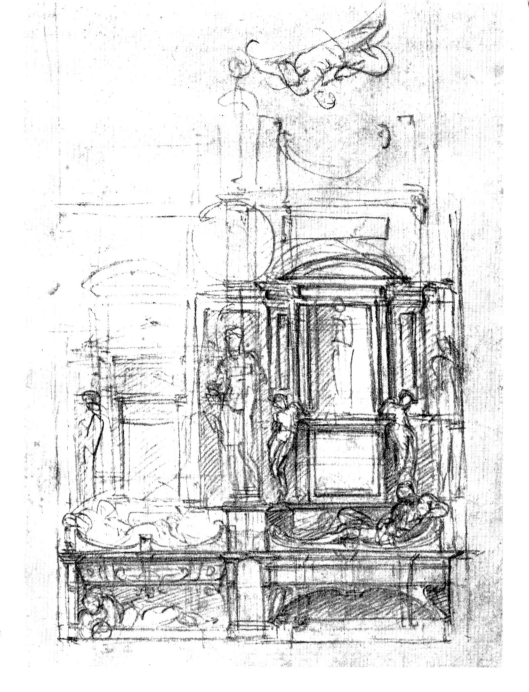

Jacopo Chimenti, known as Empoli
Michelangelo presenting his project for the façade of San Lorenzo and other Laurentian projects to Leo X, 1619
Casa Buonarroti, Florence

A new Pope and a new project followed. Cardinal Giulio de' Medici was enthroned as Clement VII in 1523; no less eager than his predecessors to employ Michelangelo, he entrusted him with the new sacristy at San Lorenzo, which was to house the Medici tombs (pp. 54-55). There were to be six tombs in all: one for Lorenzo the Magnificent, one for his brother Giuliano, one for his son Giuliano, Duke of Nemours, one for Lorenzo, Duke of Urbino, his grandson, one for Leo X, and one for Clement himself. The commission for the Laurentian library (p. 59) followed.

These projects collapsed in their turn. No blame attaches to Clement VII, who paid Michelangelo three times the salary he had asked for, and provided him with a house in San Lorenzo. He was no less assiduous in his moral support, frequently sending affectionate messages: "You know that Popes never live long, and no desire could be more ardent than our wish to see the chapel with the tombs of our family completed... along with the library. We recommend both of them to your zeal". Worried by the sculptor's health, he forbade him "to work, in any way whatsoever, save on the tomb [of Julius II] and on the work we have charged you with, so that you may the longer distinguish Rome, your family and

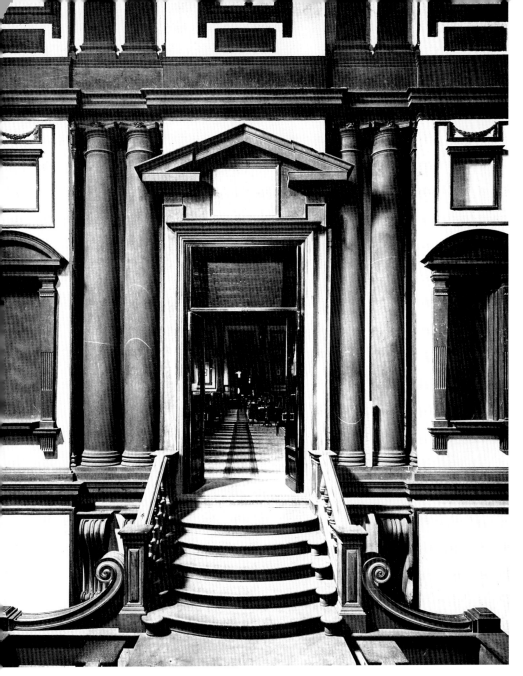

Entrance and vestibule of the Biblioteca Laurenziana
The first plans date from 1524, but the building work was finished only in 1532–1533.

Study for the façade of San Lorenzo, 1517

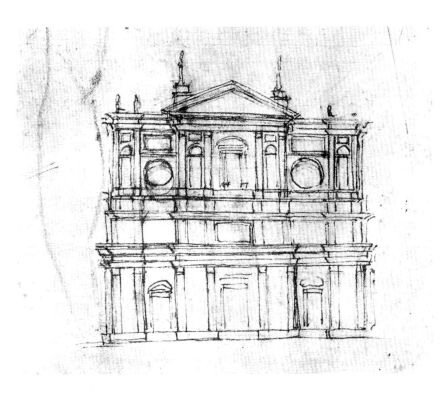

MICHELAN
BONAROTI

FACI=B
AT

60

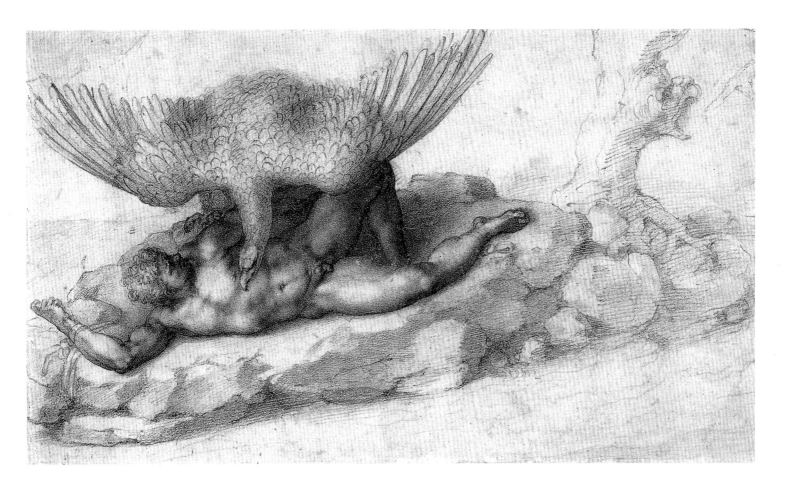

yourself". He also told him: "If someone asks you for a painting, attach a brush to your foot, make four strokes with it, and tell them: 'The painting is finished'".

While work on San Lorenzo was in full swing, revolution broke out in Florence. Unable to reconcile his love of liberty with his obligations to the Medici, Michelangelo took his place in the forefront of the rebels. The Republic asked him to take charge of the fortifications of Florence, and he threw himself into the task. But Florence was forced to capitulate. The Pope was magnanimous in victory, and pardoned the errant artist. In September–October 1530, Michelangelo again set to work to glorify those whom he had sought to overthrow.

But the Medici were no more fortunate than Julius II, and their commission was never completed. What we see today is only distantly related to Michelangelo's conception. The sculptures which survived the ruin of the project have little to do with the original subject – a homage to the Medici family. Today when we visit the chapel, we see two pairs of sculptures: *Day* and *Night* and *Dawn* and *Dusk* (pp. 54–55). The contrasting pairs entirely fail to convey Michelangelo's intended message: "By our rapid movement, we have led Duke Giuliano to his death". They survive simply as allegories of the human body's subjection to time. Who, on seeing them now, spares a thought for the Medici? Here too we feel that scorching wind that blows through the Sistine Chapel, in Romain Rolland's description. But nothing here tells of tragic expectation of the Son of Man. Mere nothingness weighs down upon these giants. As for the other sculptures, completed and planned, Vasari asked Michelangelo to tell him which niches they had been intended for, but in vain. No one ever discovered where they should have been placed.

When Michelangelo left Florence, only the vestibule and ceiling of the Laurentian library were complete. The staircase was not even begun, and when

Tityus, ca. 1533
Black chalk, 19 x 33 cm
Royal Library, Windsor

This erotic cartoon, a gift to Cavalieri, evokes the "fire" with which Michelangelo burned for the younger man.

PAGE 60:
The damned soul, ca. 1525
Black ink, 35.7 x 25.1 cm
Uffizi Galleries, Florence

Three of the tasks of Hercules, 1530
Red chalk, 27.2 x 42.2 cm
Royal Library, Windsor

Drawn as a present for Tommaso dei
Cavalieri.

the decision was taken to proceed with it, no model could be found. Vasari again asked for details. Michelangelo amicably replied:"he wasn't being difficult, he had tried to remember, that he had a vague idea – as if it had been a dream – of a certain staircase, but that he didn't believe it was the one he had intended, since it was absurd".

PAGE 63: ***The Fall of Phaeton,*** ca. 1533
Black chalk, 41.3 x 23.4 cm
Royal Library, Windsor
Phaeton was the third hero, with Tityus (p. 61)
and Ganymede (p. 1), in the erotic cycle dedi-
cated to Cavalieri, "La forza d'un bel viso…":
"To what am I spurred by the power of a beau-
tiful face? Since there is nothing else in the
world that brings me delight: to ascend, while
still alive, among the blessed spirits by a grace
so great that every other seems inferior.
If every work is truly similar to its maker, what
blame would justice have me expect, if I love,
indeed burn, and honour and esteem every
noble person as being divinely conceived?"
(Partial sonnet, 279). From *Michelangelo:
The Poems,* translated by Christopher Ryan,
J. M. Dent, 1996.

According to Romain Rolland: "He had given up on all his projects to the point where he had completely effaced them from his memory. Or rather, his memory had been effaced as they had". Michelangelo himself confessed: "My mind and memory have run ahead of me, and await me in the world to come".

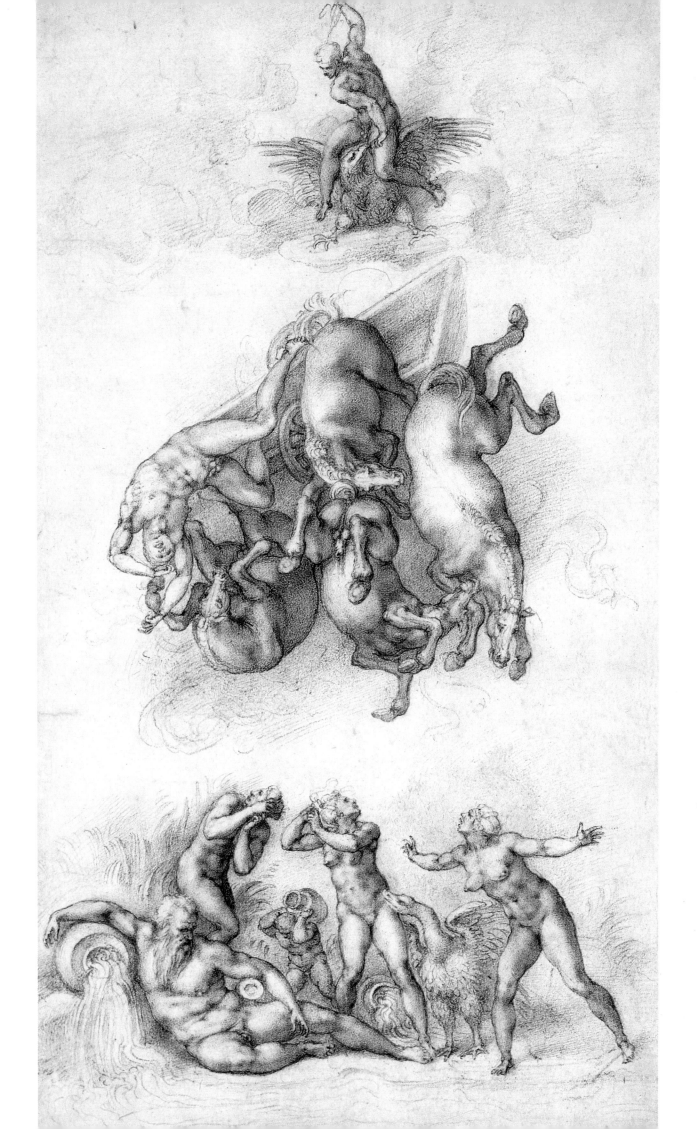

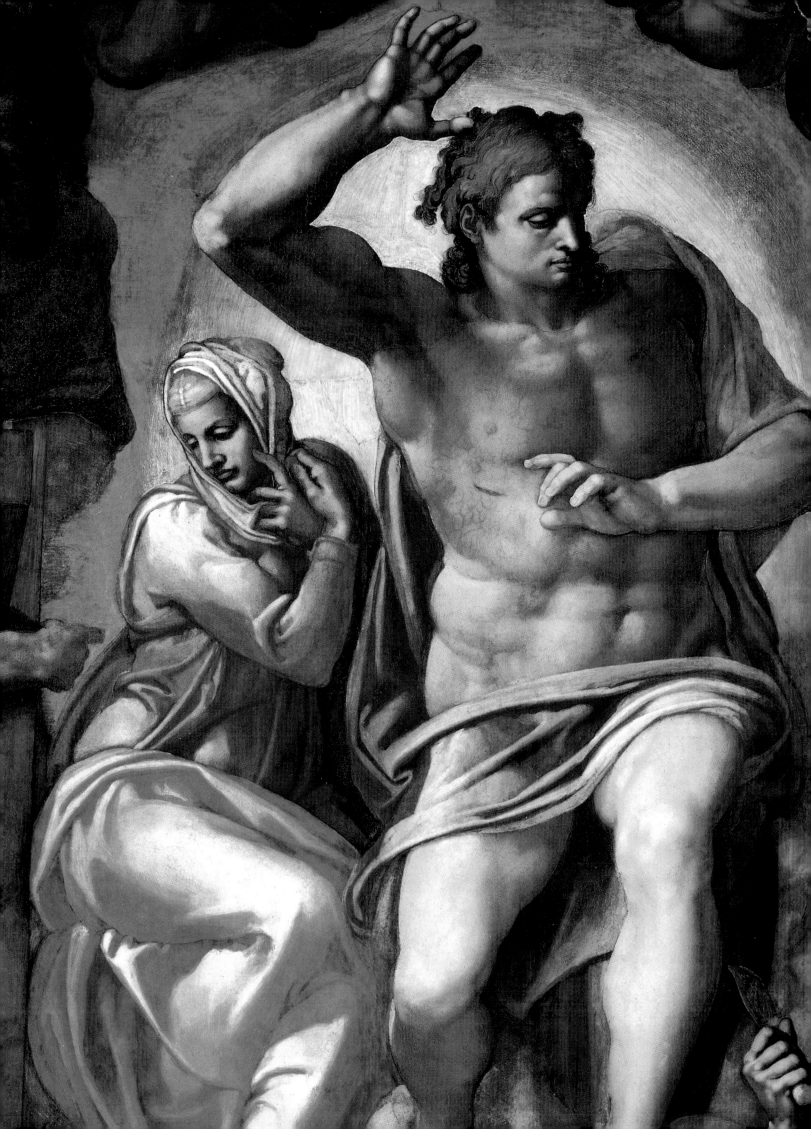

The Fires of Love 1535–1547

On 23 September 1534, Michelangelo, disappointed by his many failures, and prematurely aged by the rigours of his life, returned to Rome. He remained there until his death in 1564. Henceforth without rival, he dominated the landscape of Italian art, inspiring the admiration of all around him. Yet inwardly, he was in utter disarray. His heart was starved of love, and his intellectual solitude, deny it as he might, was unbearable. Death and sin haunted him. Convinced of his own unworthiness, he lived in terror of that "second death", eternal perdition:

"I live to sin, to kill myself I live; no longer is my life my own, but sin's; my good is given to me by heaven, my evil by myself, by my free will, of which I am deprived".

His torments had their source in the unconditional love he felt for the handsome and refined Tommaso dei Cavalieri, whom he had met in 1532. He had settled in Rome to be near his beloved. His ravaging, redemptive passion found expression in the most extravagant praise. To Tommaso, he wrote: "Your name nourishes my heart and soul, filling each with such sweetness that I no longer feel my suffering, nor do I fear death, when once I recall it. And if my eyes, too, had their share of you, only think how happy I should be".

Michelangelo's passion did not go unnoticed, and was soon the subject of gossip and odious insinuation. This was unjust; slave as Michelangeolo was to his senses and corrosive desire, his soul more than ever sought to master them. The episodes of this long and often desperate battle are recounted in his sonnets:

'But if, when near, the infinite beauty that dazzles my eyes does not allow my heart to bear up, and from afar seems not to reassure me or give me confidence, what will become of me? What guide or escort can there be who in regard of you will ever give me help or strength, if you, when near, burn me, and, by parting, kill me?'

For many years, people pretended that these poems addressed a series of hypothetical women, correcting the genders in consequence. The tradition began with Michelangelo's great nephew, who published the first edition of the poems in 1623, and lasted until Cesare Guasti's edition of 1863. This re-established the text, though Guasti dared not reveal Tommaso dei Cavalieri's historical existence. Instead, he convinced himself that behind this name was hidden the only woman whom Michelangelo ever loved: Vittoria Colonna (right).

As Pierre Leyris notes in his French edition of the poems (Editions Mazarine, 1983), "since poetry was not his profession, since there was no printer waiting for his copy, would he have written all these sonnets just to lie to

Supposed portrait of Vittoria Colonna,
ca. 1536
Pen and ink drawing over red chalk with hatching, 32.6 x 25.8 cm
The British Museum, London

ABOVE:
Study for *The Last Judgement* (detail),
1534–1535
Black chalk, 40 x 26 cm
The British Museum, London

PAGE 64:
The Last Judgement, detail: Christ and the Virgin, 1536–1541
Fresco, overall dimensions 1700 x 1330 cm
Sistine Chapel, Vatican

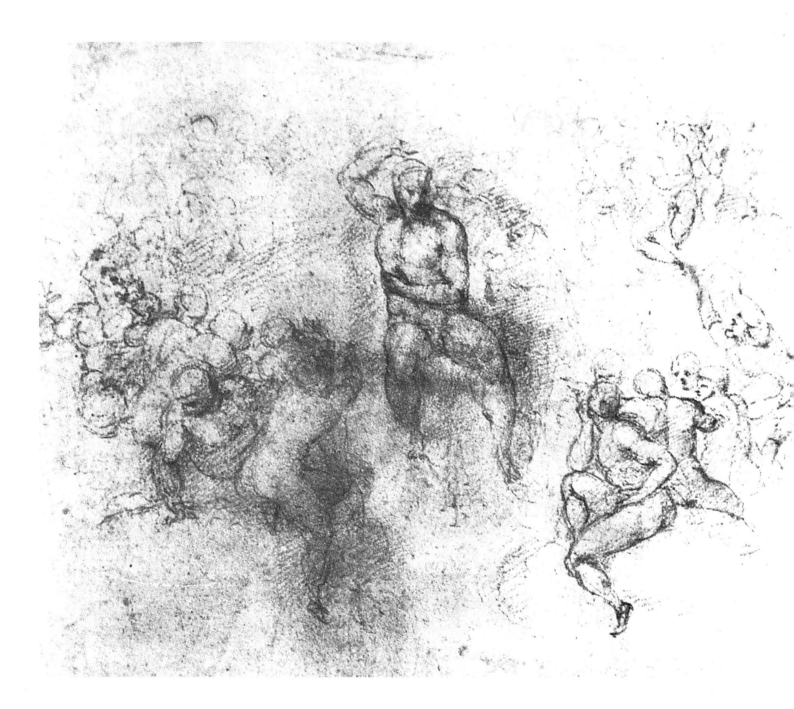

Study for the ascension of the **Apostles and the Blessed** around Christ the Judge and the Virgin for the Sistine Chapel (detail), 1535
Black chalk, 34.4 x 29 cm
Musée Bonnat, Bayonne

PAGE 67:
The Last Judgement
General overview of this vast composition which is 17 metres high and over 13 metres wide. It occupies the entire wall above the altar.

Michelangelo made the first cartoons in the autumn of 1535, and the fresco itself was completed on 18 November 1541.

himself, to lie to Cavalieri, and deceive the few friends who were privileged to read his verse? The idea is absurd, and incompatible with the asperity and rectitude of his genius". And he continues: "Up till this point, not one woman was to be seen in the entourage of Michelangelo other than the Madonnas whom he sculpted. Most of the female bodies in his work were sketched from male models or reworked classical statues". True, some of the last poems are addressed to a *donna bella e crudele*, but according to Ettore Barelli, this *donna* is "so mysteriously absent from the very full records of Michelangelo's life that she would appear to be a pretext for verse".

Michelangelo seems to have conceived only one erotic painting involving a woman, the *Leda and the Swan*. A very fine red chalk study of a head has survived (p. 49). Even this seems to have been modelled by one of the *garzoni* in his studio; the rim of a doublet can be made out at the base of the neck. For Cavalieri, by contrast, Michelangelo made many erotic cartoons, including a *Rape of Ganymede* (p. 1) and a *Tityus* showing a vulture gnawing at the hero's liver (*The Punishment of Tityus*, p. 61). Both these heroes symbolised the "fire

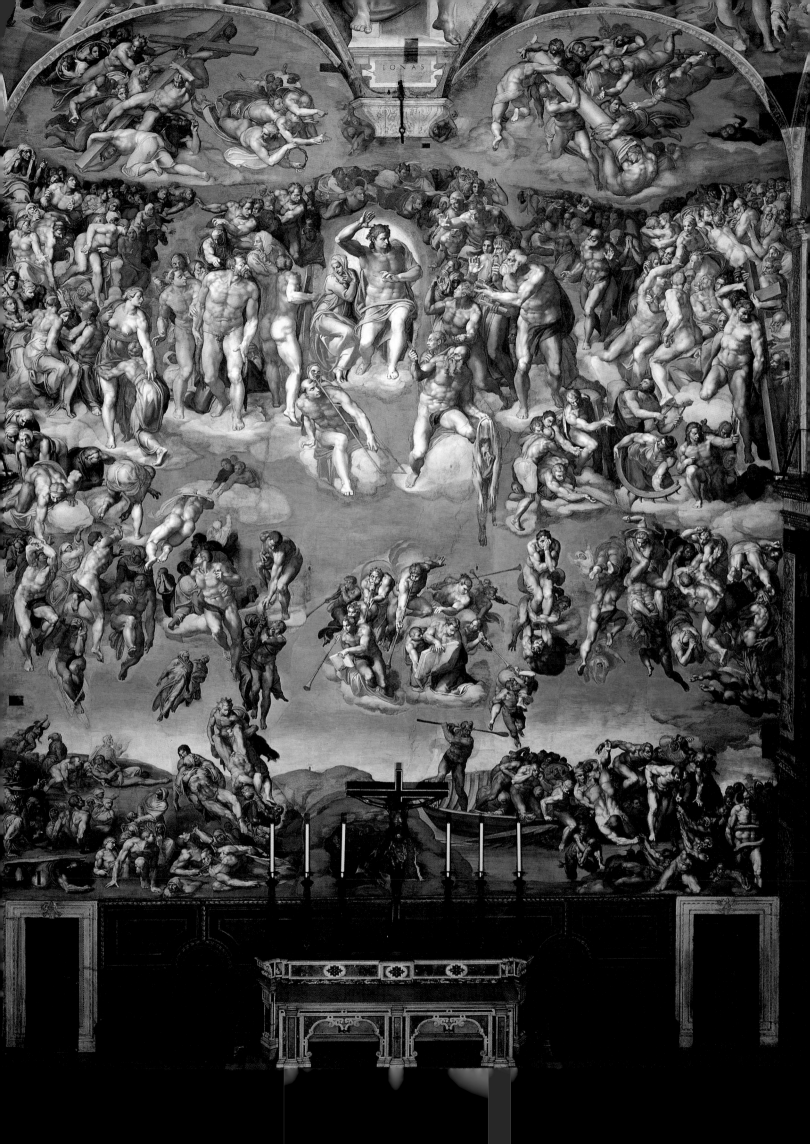

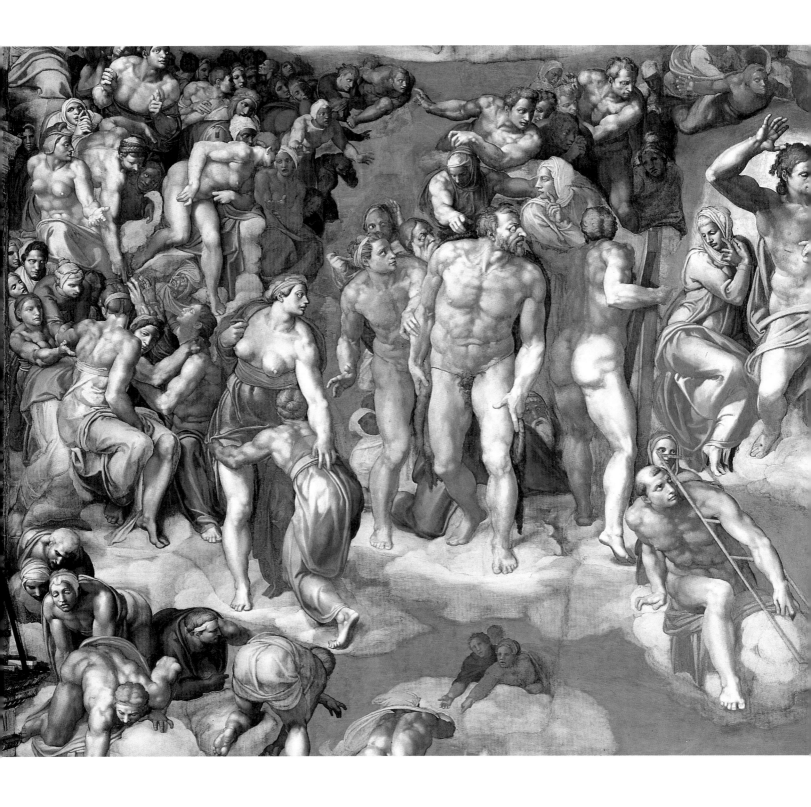

The Last Judgement (detail)
Earlier representations of the *Last Judgement*
had shown Christ the Judge as he appeared in
the description of Saint Matthew, "seated on
his throne in glory", with the apostles beside
him sitting "on the thrones of the twelve tribes
of Israel". Michelangelo's Christ scandalised
contemporary viewers because he is neither
seated, nor has he a beard. He is a handsome
young man, smooth-skinned and athletically
built, who seems to be walking forwards with
his arm raised in a gesture that marks not some

terrible and definitive damnation, but the
peace that comes with the end of time and the
cessation of the travails of human life.
Christ is surrounded by the blessed saints and
martyrs. The main figure in this group is St
John the Baptist, on the left. He is balanced by
St Peter to the right, who is offering two huge
keys to Christ, emblems of the power to bind
and to release men from sin that had been
delegated to the Popes.

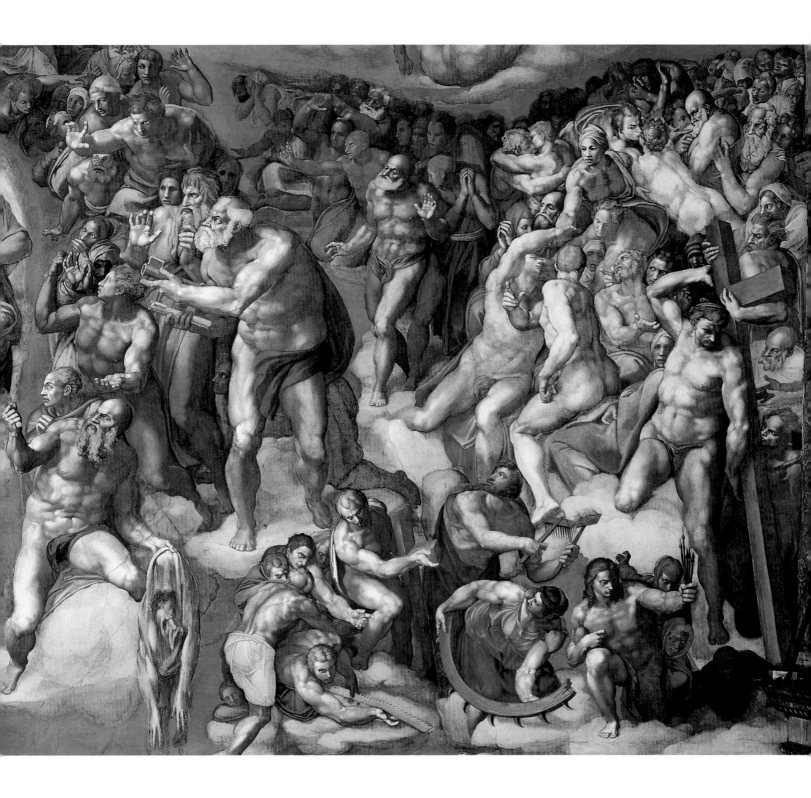

Below Christ are the figures of St Laurence, holding his gridiron, and St Bartholomew, with the skin that was stripped from him when he was martyred. This skin is clearly recognisable as a dramatic self–portrait of the artist – another sign not only of Michelangelo's terror of the "flesh" and of "sin", but also of his thirst for spiritual renewal and salvation.

For Michelangelo, the beauty of these naked bodies bears witness to the glory of the elect on the day of the "resurrection of the flesh". But for many of his first viewers, they were simply obscene, and so violent were the complaints, that the fresco ran the risk of being destroyed. Pope Paul IV however felt it would be enough to have appropriate clothing painted on to cover up the offending parts. Daniele da Volterra undertook this task, which earned him the nickname *Braghettone*. It was only in our own time, under the direction of John Paul II, that *The Last Judgement* was finally restored and recognised by the Church for what it is – "a temple dedicated to the theology of the human body".

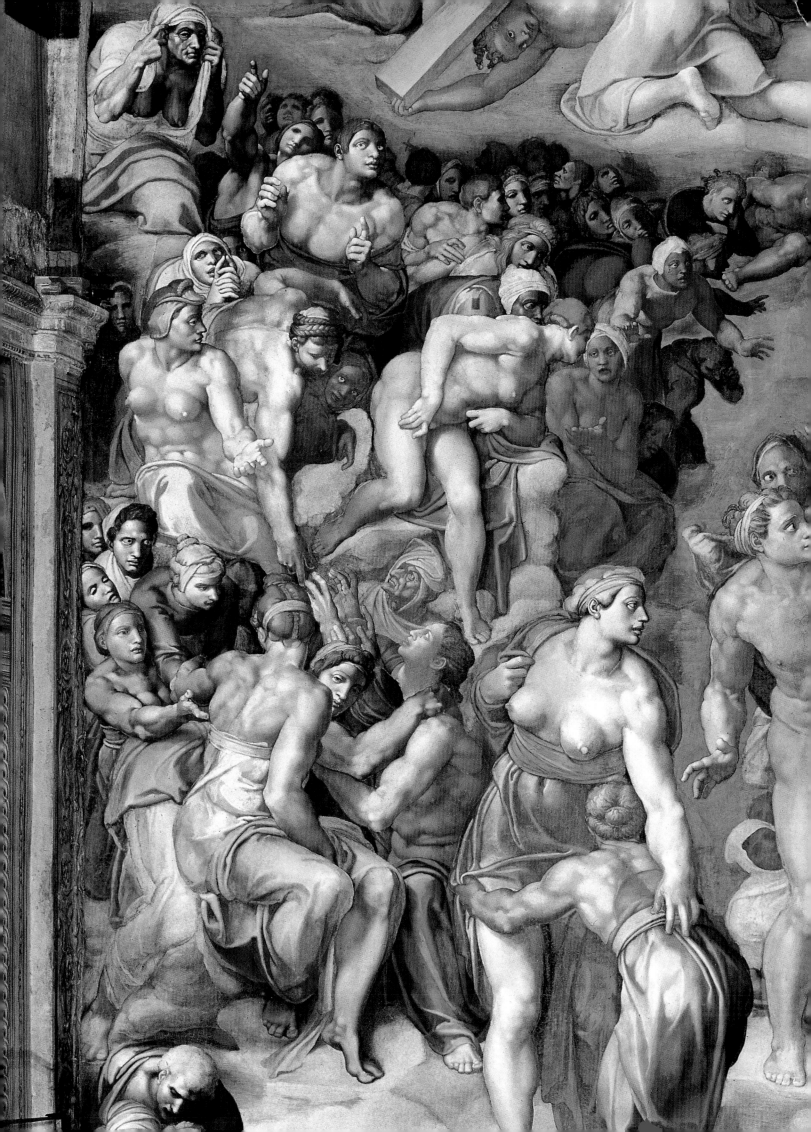

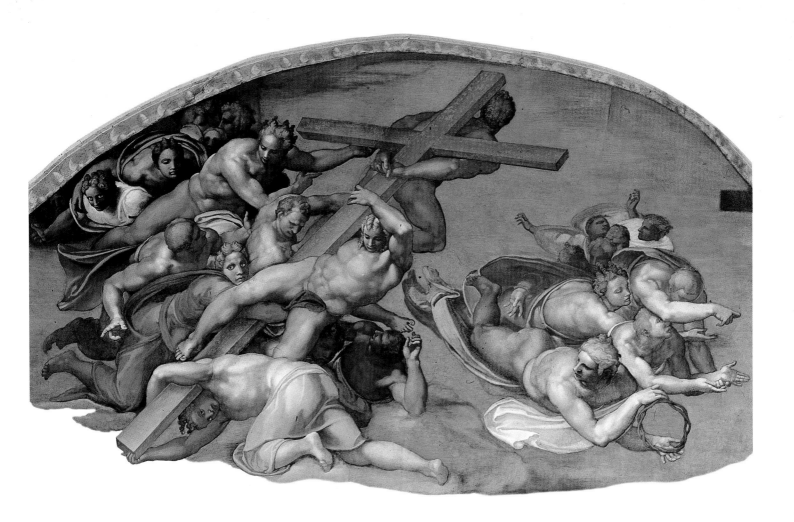

The Last Judgement (detail)
Left-hand lunette, angels lifting up the cross

that burned in him". This cycle in homage to the *bel viso* was completed by a third hero, *Phaethon* (p. 63) in his chariot hurtling down into the Po.

There was only one woman in Michelangelo's life; and she was not a lover, but a spiritual companion. This was Vittoria Colonna, the Marchesa of Pescara (p. 65), for whom he made a series of religious drawings. In 1538, they met every Sunday at the Dominican convent of San Silvestro at Monte Cavallo. Colonna was a widow with a severe, masculine face. In one of his madrigals, Michelangelo himself described her as *Un uomo in una donna*. According to Condivi, "he was in love with her divine mind". Tormented by religious doubts, Colonna withdrew into a convent, but periodically returned to Rome to calm her friend and exhort him to work, despite the doubts and despair by which he was haunted. Thanks to her he regained his faith, from which he never again departed. In a madrigal dedicated to her, he wrote that she was "a true mediator between himself and Heaven, a *divina donna*"; he begged that she would deign to lower herself to him, so that his misery might rise with her up the steep road of salvation. In some ways, Vittoria was to Michelangelo what Beatrice had been to Dante, whose verse the sculptor knew by heart. Michelangelo seems to have been deeply marked by this spiritual friendship. They were, in Vittoria's words, "bound by the ties of the Christian knot". According to Tolnay, her inspiration is perceptible in countless details of *The Last Judgement* in the Sistine Chapel, on which Michelangelo was then working.

Again there came a new Pope with a new project. Paul III Farnese succeeded Clement VII. Seeking, in his turn, to restore the authority of Rome and the Church, he revived an old project of Michelangelo's, commissioning

PAGE 70:
The Last Judgement (detail)
On the far left of the ring made by the blessed stand the women – saints, virgins and martyrs, along with the sybils and the heroines of the Old Testament. The gigantic figure, who seems to be protecting a young girl who kneels beside her, is usually identified as Eve.

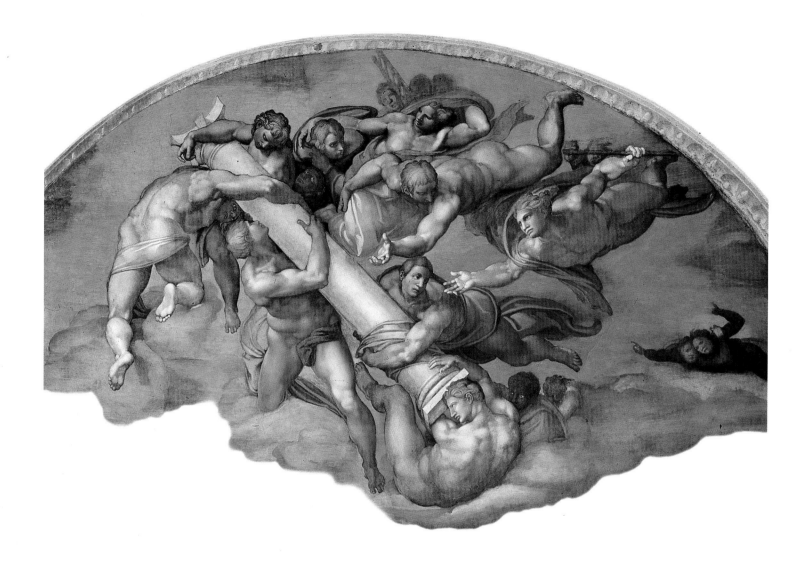

The Last Judgement (detail)
Right-hand lunette, angels lifting up "the column of the flagellation", which tilts towards the centre of the wall, as if to balance the cross in the left-hand lunette.

PAGE 73:
The Last Judgement (detail)
A group of the elect standing to the right of Christ. The huge figure holding the cross has been variously identified as the Cyrenean who came to Christ's help on the way to Calvary, and as Dismas, the good thief. Below to the right, the St Sebastian is a fine example of a classical nude. He clasps in his hand the arrows which are the symbol of his martyrdom. To the left, Catherine of Alexandria turns towards St Blasius. In the original picture, both of them were entirely naked, and Catherine's gesture – looking towards the man's sex, a pose of which Michelangelo was very fond (*Doni Tondo*, pp. 10–11, *Adam and Eve*, p. 36) – scandalised contemporary viewers. Fortunately, the Braghettone was on hand to draw a veil over this "immodest gesture".

The Last Judgement. To ensure his allegiance, he issued a brief dated 1 September 1535, appointing the artist chief architect, sculptor and painter to the apostolic palace, with a lifelong pension of 1200 gold écus *per annum*. In return, Michelangelo undertook to finish the decoration of the Sistine Chapel and replace the frescoes of Perugino, which then covered the great wall above the altar. This last part of the project must have delighted Michelangelo, who despised Perugino as an "old fogey". From 1536 to 1541, Michelangelo worked relentlessly on the *Judgement*. Nothing could stop him - not even a fall from the scaffolding in which he severely injured his leg. The immense work was completed on Christmas Day 1541.

Once more, the public were greeted by the sight of a huge surface (17 m high by 13 m wide) seething with hundreds of figures. This colossal, overpowering achievement was the work of an old man, aged between sixty-one and sixty-six. It proved, if proof was necessary, that a lifetime exhausted by hard labour and wracked by torment had not undermined the vitality of this "terrible" man, as Julius II once called him. Pope had succeeded Pope, but Michelangelo remained. Age had not moderated him. Terror and death inhabit this proliferation of gigantic bodies. Their accumulation imparts a suffocating malaise as clusters of them are whirled around the central figure of an athletic, beardless Christ (p. 64), to be sucked down at the last into the abyss.

Saints and martyrs (pp. 68-69) brandish the instruments of their torture. Even the Virgin averts her gaze from the spectacle (p. 64). Above, souls and

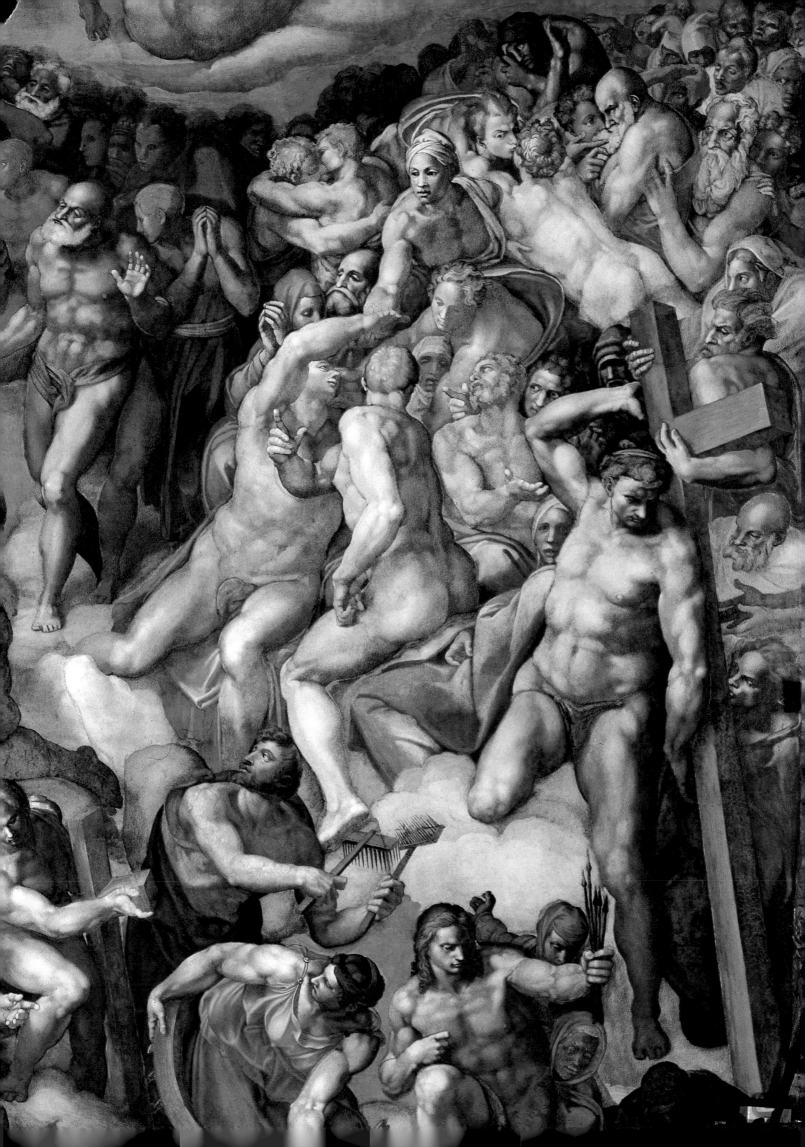

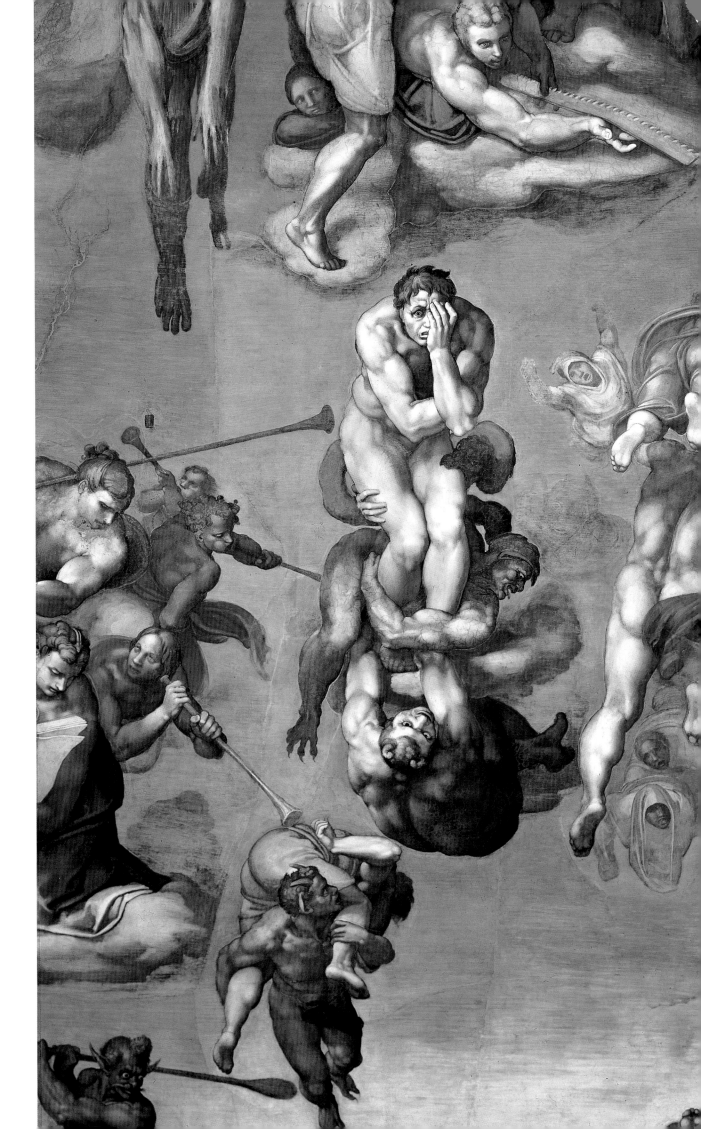

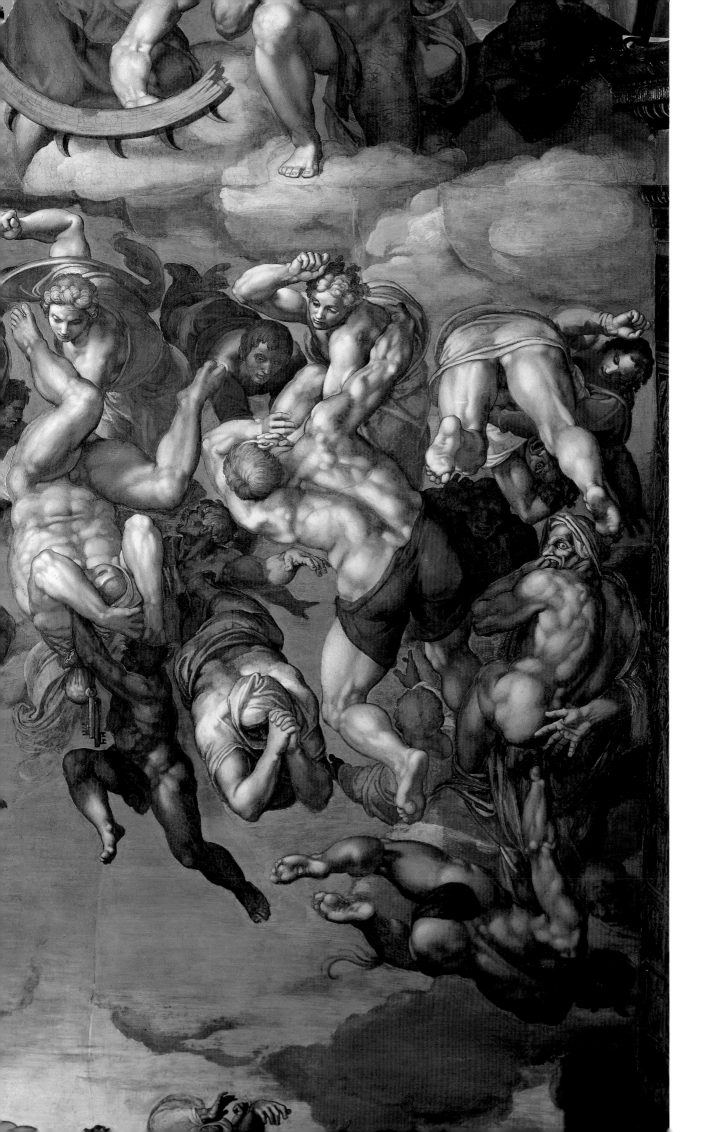

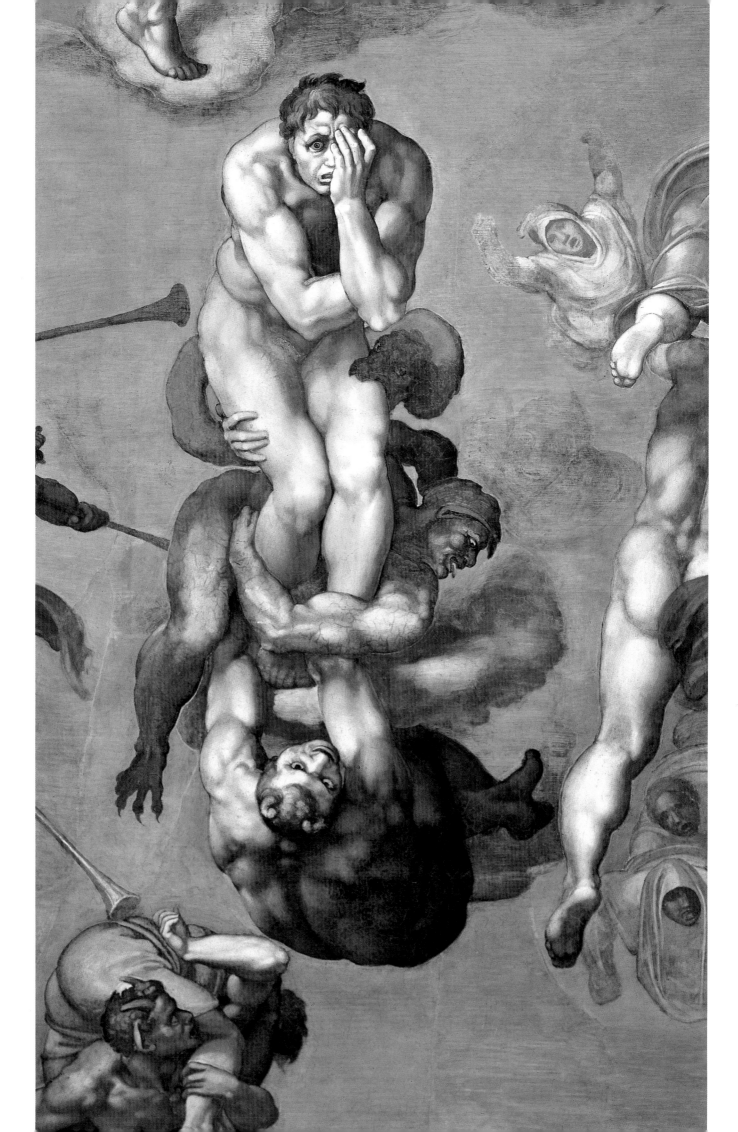

angels conduct an unbridled fist fight. Below, a Charon who owes much to Dante (*Inferno,* III, 109 ff.), "with his eyes like embers, beats with his oars" the damned who pile up before him like lambs to the slaughter, while the demons seize upon the screeching souls (pp. 74–76).

"In such a work", notes Romain Rolland, "there is an accumulation of anger, vengeance and hatred. If these emotions were not purified by an enormous, almost elemental energy, they would be unbearable. This, then, is what the *Prophets* and the *Sibyls* were waiting for! This is the meaning of the convulsive agony of the paintings on the vault above! ... This implacable conclusion to human history was certainly consistent with the essence of Christian thought; but the way in which it was expressed was so daring, so uninhibited, that most Christians were revolted by it. Michelangelo, an aristocratic in his faith as in all things, was unconcerned by this reaction."

The Pope's chamberlain, Biagio da Cesena, stated publicly "that it was a most dishonest act in such a respectable place to have painted so many naked figures immodestly revealing their shameful parts, that it was not a work for a papal chapel but for a bathhouse or house of ill-fame". Michelangelo took his revenge on Biagio by adding his portrait to the damned; in the guise of Minos, he looks on impassive and depraved, "with a huge serpent coiled around his legs, in the midst of a crowd of devils".

Biagio's verdict was a common one. N. Serni reported to Cardinal Gonzaga, an intimate of the Pope: "… although the work is as beautiful as you might imagine, your Grace, the hypocrites are the first to find the nudes incongruous in such a place because they display certain parts of their anatomy. Others say that Michelangelo has depicted Christ without a beard, that he has made him too young and that he lacks the requisite majesty. Thus there is no lack of people to criticise, but the Reverend Cornaro, after long consideration of the work, declared that if Michelangelo would give him a painting depicting just one of these figures, he would pay him whatever he asked, and he is right for, in my opinion, these are things that can be seen nowhere else".

Aretino – author of the *Hypocrite* (a prototype of Moliere's *Tartuffe*) – resented Michelangelo's lack of respect for him. He mounted a cabal, secretly campaigning to have the work destroyed pure and simply. "Fiery flames" he said, should be made "of the shameful parts of the damned, and rays of sunlight out of those of the blessed". Neither Michelangelo's European-wide renown nor his favour with the Popes sufficed to protect *The Last Judgement* from the zeal of the pious. Paul III's successor, Paul IV Carafa, instructed the painter Daniele da Volterra to clothe the parts so offensive to the licentious poet Aretino. Volterra thus (1559–1560) earned the sobriquet *Braghettone.* Michelangelo impassively watched the mutilation of his work, commenting "Tell His Holiness that this is a small matter, which can easily be rectified. Let His Holiness attend to the reform of the world: reforming a painting is easily done".

Fig-leaves aside, the true subject of *The Last Judgement* is the foundering of a civilisation. A tormented and suffering humanity has seen its moral and intellectual certainties collapse; terrified, it awaits the promised resurrection of the dead under the aegis of Christ the judge and redeemer, when the world is overthrown at the end of time (Pier Luigi de Vecchi).

The painting is also a turning point in the history of art. After it, nothing was ever the same again. Its inauguration attracted visitors from the whole of

Scherzo, or the torments of the flesh, v. 1512
Museo del Vaticano,
Doria-Pamphili collection
A self-portrait that the conservators of the Vatican usually keep well-hidden.

PAGES 74–76:
The Last Judgement
Detail: The Resurrection of the Body
The damned are being sucked down into hell. They are reminiscent of the descriptions in Dante's *Inferno,* which Michelangelo knew by heart. The judgement passed on them is represented by the figure (left-hand page) who seems to be suffering an inner torment, similar to that of the artist himself: despair, remorse, and the fear of physical and spiritual annihilation.

The punishment of the sodomites
Copy by Witkowski after the fresco.

Satyr's head, undated
Brown ink, 28 x 21 cm
Musée du Louvre, Cabinet des dessins, Paris

PAGE 79:
The Last Judgement (detail)
Saint Bartholomew is one of a group of saints
who are pictured brandishing the instruments
of their martyrdom. Skinned alive, he is hold-
ing his skin in his hands: in this second face of
his appears a celebrated self-portrait of
Michelangelo.

Italy and Europe. Italian, Flemish, French and German artists flocked to the Sis-
tine Chapel, unabashedly copying the fresco item by item. Aretino had hoped to
crush his rival, but Michelangelo's renown was now on a scale with his cre-
ations. Today it is literally worldwide; the experts who undertook the restoration
of the work are Japanese. Vasari predicted the phenomenal impact of the work:
"This sublime painting", he wrote, "should serve as a model for our art. Divine
Providence has bestowed it upon the world to show how much intelligence she
can deal out to certain men on earth. The most expert draftsman trembles as he
contemplates these bold outlines and marvellous foreshortenings. In the pres-
ence of this celestial work, the senses are paralysed, and one can only wonder at
the works that came before and the works that shall come after".

And what was to become of the monument to Julius II? In 1542, a sixth and
final contract was signed with his heirs. Michelangelo ceded ownership of three
statues, including the *Moses*, and reimbursed 1400 écus.

The nightmare that had dominated his life was at an end. The loss is ours. If
his dream had been realised, it would have been to sculpture what the Sistine
Chapel is to painting.

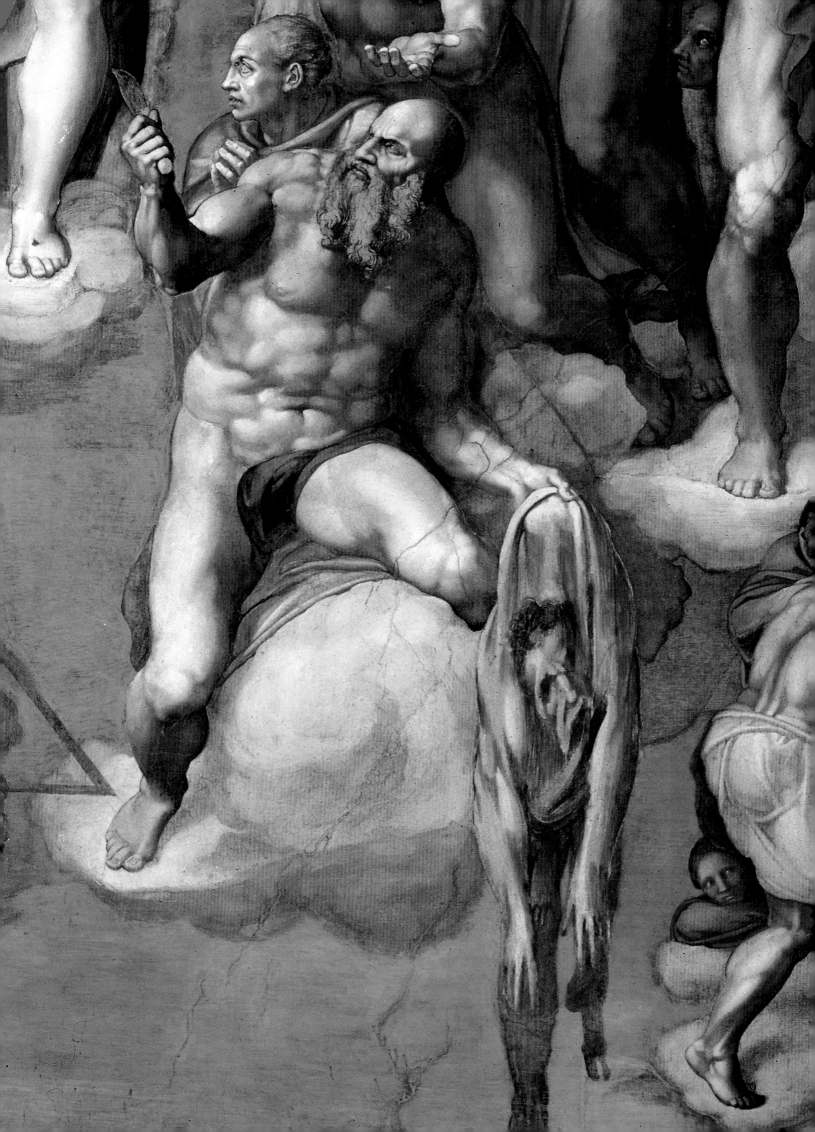

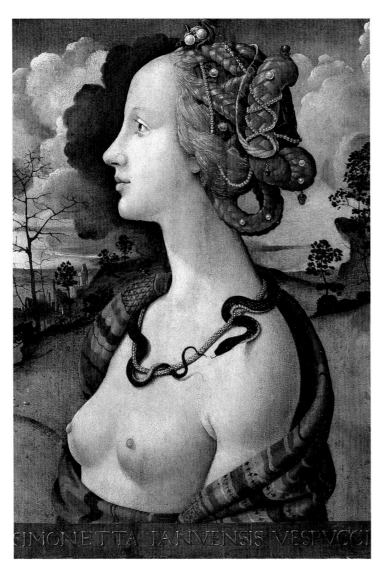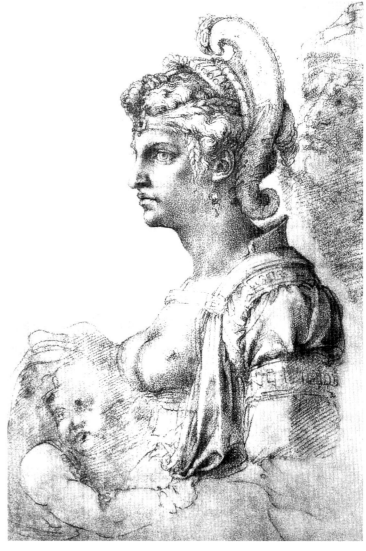

ABOVE:
Piero di Cosimo
Portrait of Simonetta Vespucci, ca. 1480
Oil on panel, 57 x 42 cm
Musée Condé, Chantilly
This portrait was almost certainly the inspiration for Michelangelo's *Cleopatra* (page 81).

RIGHT:
Allegorical figure, ca. 1530
Casa Buonarroti, Florence
One of the drawings which Vasari referred to as "The Divine Heads": the pose is the same as in the painting by Cosimo.
Michelangelo painted portraits of women as well as men, though in both cases his models were chosen among his *garzoni*.

Yet none of the *Prophets* in the Chapel rivals the supreme perfection of the *Moses*. Like a magical mirror, this statue held up before the artist the idealised portrait of his soul. Nowhere else as in this masterpiece did he achieve the same balance between the fury of the soul and the iron of the will that has mastered it. As for the other remains of this ruined project, they are best passed over in silence.

PAGE 81:
Cleopatra, ca. 1533–1534
Black chalk, 35.5 x 25 cm
Uffizi Galleries, Florence

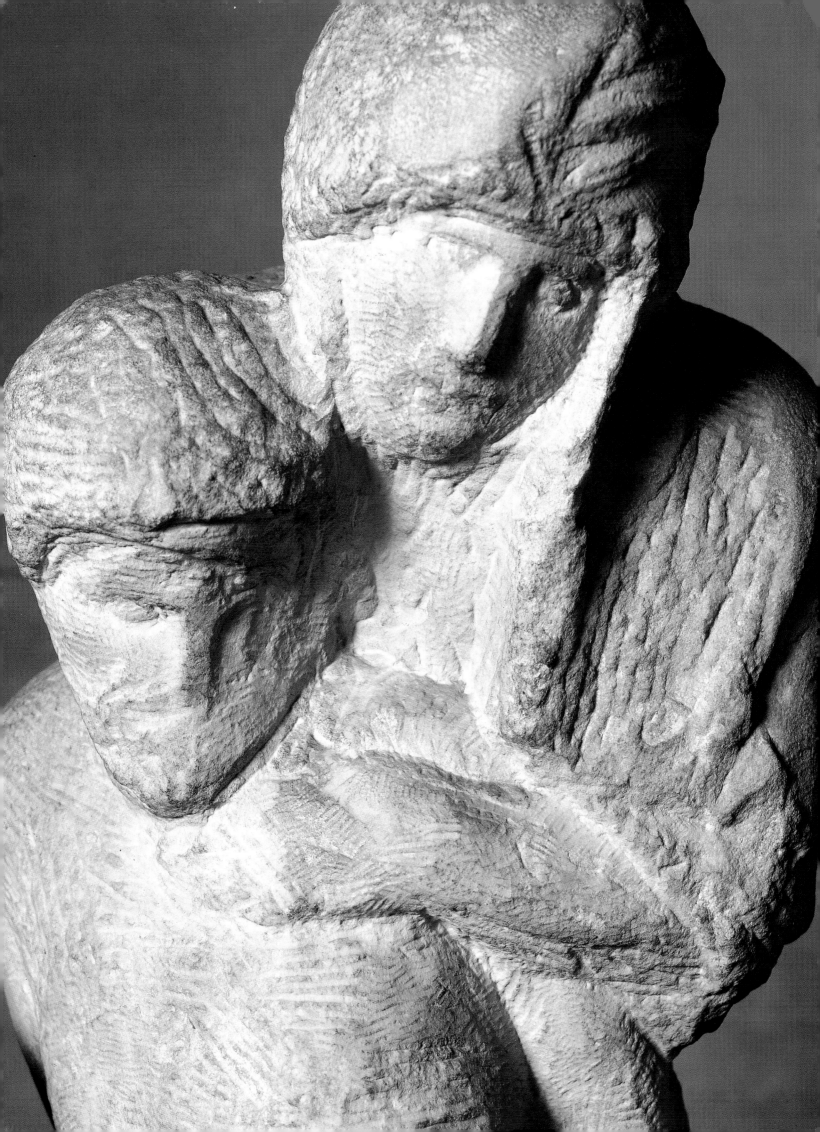

The Glory of God 1547–1564

When Vittoria Colonna died in 1547, Michelangelo was stupefied with grief, and, in Condivi's words, 'like one mad'. Condivi adds that Michelangelo 'had never suffered a greater pain in this world than to have let her depart this life without kissing her brow or face, but only her hand'.

The artist was now seventy-two years old. He was suffering from gall stones and racked with regret at the "great mistake" he had made throughout his life, namely "the fond imagination, which made art for me an idol and a tyrant". Henceforth his soul would be exclusively focused on "that divine love which, on the cross, to embrace us, opened wide its arms". The only glory that concerned him was the glory of God. The work of his last twenty years – poems, drawings, sculptures and buildings – all tended to the same end: to raise temples to God, of which the foremost was St Peter's. Writing to his nephew Lionardo Buonarroti in 1557, he declared: "Many people believe, as I do, that this task has been placed before me by God… I do not want to shirk it, for I serve from love of God, in whom I place all my hopes".

Delivered from the "goad of the flesh" (St Paul), and "no longer believing as he once did that the contemplation or recreation of human beauty could in any way lead to God, Michelangelo came to renounce an art based on beauty, along with the 'vain thoughts of love' of his earlier years" (Pierre Leyris). He wrote his recantation, a *mea culpa:*

"My life's journey has finally arrived, after a stormy sea, in a fragile boat, at the common port, through which all must pass to render an account and explanation of their every act, evil and devout.

So now I fully recognize how my fond imagination, which made art for me an idol and a tyrant, was laden with error, as is that which all me desire to their own harm.

What will now become of my former thoughts of love, empty yet happy, if I am now approaching a double death?* Of one I am quite certain, and the other threatens me.

Neither painting nor sculpting can any longer quieten my soul, turned now to that divine love which on the cross, to embrace us, opened wide its arms". From *Michelangelo: The Poems,* transl. by C. Ryan, J. M. Dent, 1996.

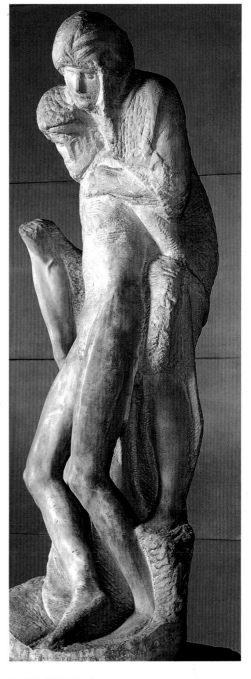

ABOVE AND PAGE 82:
Pietà Rondanini, unfinished, 1564
Marble, height 195 cm
Castello Sforzesco, Milan

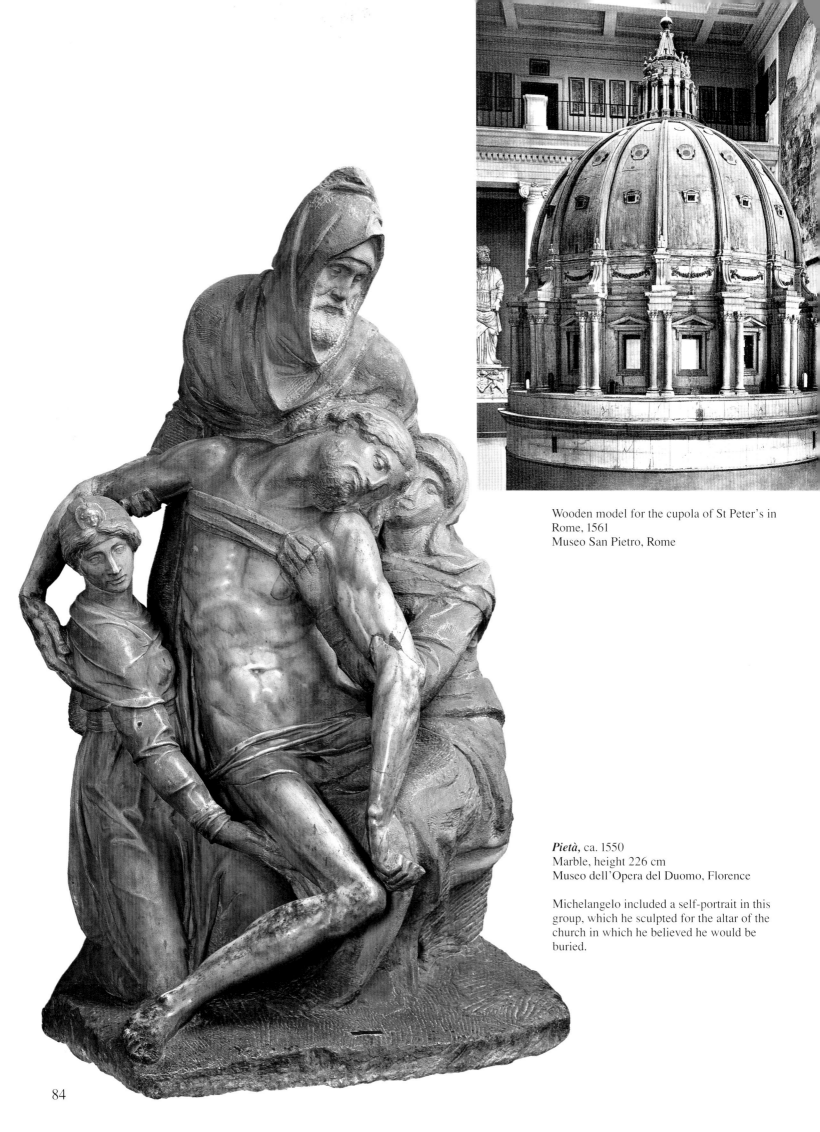

Wooden model for the cupola of St Peter's in Rome, 1561
Museo San Pietro, Rome

Pietà, ca. 1550
Marble, height 226 cm
Museo dell'Opera del Duomo, Florence

Michelangelo included a self-portrait in this group, which he sculpted for the altar of the church in which he believed he would be buried.

ABOVE:
Engraving by Etienne Dupérac after Michelangelo's plan for St Peter's, Rome
Cabinet des estampes, Bibliothèque de France, Paris

RIGHT:
The Capitoline Hill, Rome, as redesigned by Michelangelo.

(*) *"The death of the body and the damnation of the soul". – Note by Pierre Leyris.*

Michelangelo was not diminished by age. His strength of character and body remained. "His genius and his strength alike", said Vasari, "needed the act of creation... He attacked a block of marble, cutting out of it four figures larger than life, amongst them the dead Christ (The *Pietà,* p. 84 – detail of Michelangelo's self-portrait as Nicodemus, p. 89); he did it to entertain himself and pass the time, and, as he said, because the physical exercise of working with the chisel kept him in good health". He slept very little, so that he could work day and night: "he had made himself a cap of card, and carried a lighted candle in the middle of it, on the top of his head, so that he could have his hands free and still see what he was doing". Even at this age, he still carved marble "with such fury one felt that the stone must shatter; he would break off big fragments, three or four inches thick, with a single blow, cutting them so close to the line, that if he had gone a hairsbreadth further, he risked losing everything".

And indeed, that is what happened to the *Pietà,* which was spoiled, either because the block was hard and full of volcanic slag, or because Michelangelo was not satisfied with his work. He lost patience, and smashed the work. He would have completely destroyed it, if his servant Antonio had not insistently begged him for it. It was later restored by Michelangelo's friend, the Florentine sculptor Tiberio Calcagni, who also finished off some of the figures.

For Michelangelo, the sculpture was present in the block of stone. The artist's task was simply to extract it. In his youth, when he was working on the *David,* his genius was at once hectic and hesitant. He would sketch out works in stone with furious energy, then abruptly lose interest, unable to bring himself to

Study for the **Porta Pia,** ca. 1561
Black chalk, brown ink, brush and brown
wash, white gouache, 44.2 x 28.1 cm
Casa Buonarroti, Florence
This study was part of a project for the
renovation of the surrounding area, organised
by the Pope.

PAGE 87:
**Christ crucified between the Virgin and
Nicodemus,** ca. 1552–1554
Black chalk, brown wash and white lead,
43.3 x 29 cm
Musée du Louvre, Cabinet des dessins, Paris
"… We must traverse the columns to go
towards God…" (Paul Valéry)

complete them. The unfinished appearance of his last sculptures is quite differ-
ent; Michelangelo could conjure the most powerful emotions from blocks of
stone still rough from the quarry. The *Pietà* (p. 84) and the *Rondanini Pietà*
(pp. 82–83) are more humane, and speak directly to the soul. They are a com-
pound of suffering and love. Once again, Michelangelo revealed himself entire,
depicting himself as a cowled old man (p. 89); wearing an expression of intense
melancholy and tenderness, he props up the body of his dead Saviour.

Devoting himself to "the glory of God", Michelangelo undertook a series
of projects that mark a turning point in the architecture of the second half of the
16th century. Once again, his achievement rested less in abstract systems of pro-
portions than in his perfect knowledge of human anatomy, and a dynamic, ex-
pressive conception of the body in movement: "It is certain", he wrote, "that the
elements that make up the framework of a building are akin to the limbs of the

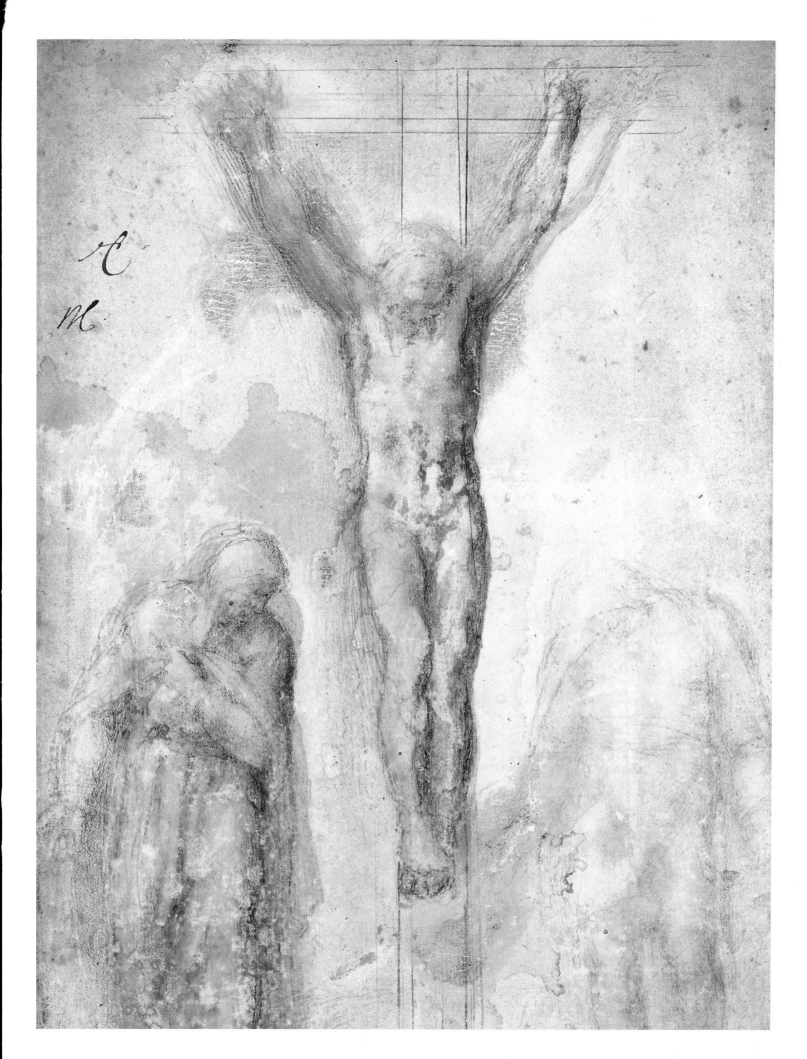

"The fables of this world have taken from me the time given for contemplating God; and not only have I disregarded God's graces, but, because of these, I have more fully turned to sin than had I lacked them.

What makes others wise makes me blind and foolish, and slow to recognize the error of my ways; hope fades, and yet my desire increases that by you I may be freed from selfish love.

Halve for me the road that climbs to heaven, my dear Lord; and even to climb that half I have need of your help.

Make me hate all that the world values, and all its beauties that I honour and revere, so that before death I may lay hold of life eternal."

Michelangelo (Sonnet sent to Monsignor Ludovico Beccadelli, March 1555; 288). From *Michelangelo: The Poems,* translated by Christopher Ryan, J. M. Dent, 1996.

PAGE 89:
Pietà (detail), ca. 1550
Michelangelo worked on this sculpture during the last days of his life. It shows mother and son united in their pain for the salvation of humanity.
In the year of Michelangelo's death, Vasari wrote to Lionardo Buonarroti of this Pietà: "... and he represented himself as one of the old men". According to tradition, Nicodemus himself was a sculptor, and made the Volto Santo in the cathedral in Lucca.

body. Only a man who can reproduce the human figure and is well-versed in anatomy knows anything about architecture".

Those lacking such qualifications conspired to prevent Michelangelo finishing St Peter's (p. 84) and the Capitoline Hill (p. 85) in Rome. Fuelled by his own anger and encouraged by the support of the Popes, he contrived to complete both. What infuriated everyone, the Pope included, was the secrecy in which the artist shrouded his work. At the completion of the apse of St. Peter's, Michelangelo had still not divulged his plans for the vault. When questioned by a cardinal, Michelangelo (in Vasari's account) replied: "I am not obliged to inform Your Excellency, or indeed anyone else, what I can or will do. Your business is to supervise the accounts and see that nothing is stolen. My business is to take care of the construction of the building". Then, turning to Pope Julius III, he added: "Holy Father, see what I earn for my pains. If the hardships I bear do not profit my soul, all this is time and effort wasted". The Pope, who loved him, put his hands on Michelangelo's shoulders, and exclaimed: "Both body and soul are gainers, do not fear". Despite attempts to lure him away, Michelangelo stayed in Rome until his "plan could be neither destroyed nor changed, and the thieves could not again set to work, as all those rascals had been hoping".

On 12 February 1564, Michelangelo spent the whole day working on his *Pietà*. On the 14th, he started a fever. He was 89 years old and it was raining, but he went riding in the *campagna* nonetheless. He refused to take to his bed until the 16th. On the 18th, he was dead. His secretary, Daniele da Volterra, and his faithful friend and inspiration, Tommaso dei Cavalieri, were at his side. The Pope wished to have the painter buried in St Peter's, but Michelangelo had expressed the desire "to return to Florence when I am dead, since I was unable to return alive". Thus, on 10 March 1564, he returned to his native city. In the sacristy of the church of Santa Croce, his coffin was opened. The body was found to be intact, as if sleeping. He was dressed in black damask. On his head was a felt hat in the antique style; on his feet, he wore boots with spurs. As in life, so in death, he rested fully clothed, ready to get up and return to work.

It was Michelangelo's curse to remain a colossus apart from and outside his time, alone in the solitude of his genius. Modern artists, in particular, have accused him of placing too much faith in the imitation of nature. As Fernand Léger put it: "the Michelangelesque ability to imitate a muscle… is productive of neither progress nor a hierarchy in art". His achievement remains, beyond all such question or dispute. It is the birthright of the comet to inspire fear and awe. The spectacle of such glory can sear the tender eye.

Chronology

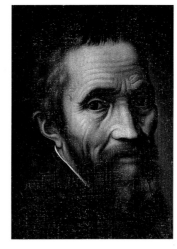

Giuliano Bugiardini
*Portrait of Michelangelo in
a turban* (detail)
Oil on canvas, 55.5 x 43.5 cm
Casa Buonarroti, Florence

Marcello Venusti
*Portrait of Michelangelo at
the time of the Sistine Chapel,*
ca. 1535
Casa Buonarroti, Florence

MICHELANGELO

1475 6 March, birth of Michelangelo Buonarroti at Caprese.

1488 Apprenticeship in Ghirlandaio's workshop.

1489 Enters the "Medici casino".

1490–1492 Lives in Lorenzo de' Medici's palace on Via Larga.

1494 October–1495 November: visits to Venice and Bologna.

1496 25 June departure for Rome.

1498 August–1499 The St. Peter's *Pietà*.

1501 16 August commissioned to sculpt the *David* in marble for the piazza della Signoria.

1503 Florence commissions twelve statues of the apostles; later cancelled in 1505.

1504 The *Pitti, Taddei* and *Doni Tondos.*

1505 Pope Julius II asks Michelangelo to design his tomb.

1506 21 November, Bologna, Julius II commissions a bronze statue for the façade of San Petronio.

1508 In April in Rome, he begins work on the decoration of the Sistine Chapel ceiling.

1508–1512 Sistine Chapel frescoes; officially inaugurated on 31 October 1512.

1518 19 January contract for the façade of San Lorenzo (never executed).

1519 Commission for the Medici tombs.

1524 Projects for the Biblioteca Laurenziana in Florence. Executes *Dusk* and *Dawn* for the tomb of Lorenzo de' Medici.

ARTS

1482 Death of Hugo van der Goes.

1483 Birth of Raphael.

1489 (?) Birth of Correggio.

1490 (?) Birth of Titian.

1494 Death of Ghirlandaio / birth of Rosso Dürer's first journey to Venice.

1497 Birth of Holbein the Younger.

1499 Alde Manuce publishes *Hypnerotomachia Poliphili* by Francesco Colonna.

1502–1503 Rome, Bramante's Tempietto at San Pietro in Montario.

1502–1510 Construction of the Château de Gaillon for the Cardinal of Amboise.

1503 Birth of Parmigianino / façade of the Belvedere Villa, by Bramante.

1504 Leonardo visits Florence.

1504–1505 Birth of Primaticcio.

1505 Dürer visits Venice.

1506–1509 Erasmus travels to Italy.

1508 Birth of Andrea Palladio.

1509–1511 Raphael's *Stanze.*

1510 (?) Birth of Jean Goujon.

1510 Deaths of Botticelli and Giorgione.

1511 Birth of Giorgio Vasari.

1514 Death of Bramante (born in 1444); Raphael succeeds him as chief architect of St Peter's.

1515–1516 Ariosto: *Orlando Furioso.*

1516 Deaths of H. Bosch and G. Bellini.

POLITICS AND RELIGION

1492 Death of Lorenzo the Magnificent in Florence.

1494 French expedition against Italy.

1498 Louis XII becomes King of France / death of Savonarola.

1500 Birth of Charles V.

1503 Giuliano della Rovere is elected Pope, as Julius II.

1507 Sale of indulgences for the construction of St. Peter's in Rome.

1509 French victory at the Battle of Agnadello.

1510 Luther travels to Rome.

1512 Louis XII captures Milan.

1512–1517 Fifth Lateran Council.

1513 Election of Pope Leo X (son of Lorenzo de' Medici).

1515 François I, king of France / French victory at the battle of Marignano.

1516 Concordat of Bologna between Leo X and François I.

1517 Luther nails his 95 theses against indulgences to the door of the chapel in Wittenberg.

1519 Charles V is elected Holy Roman Emperor.

1520 Luther is excommunicated.

1521 Adrian VI is elected Pope.

1523 Clement VII, Giulio de' Medici succeeds Adrian VI.

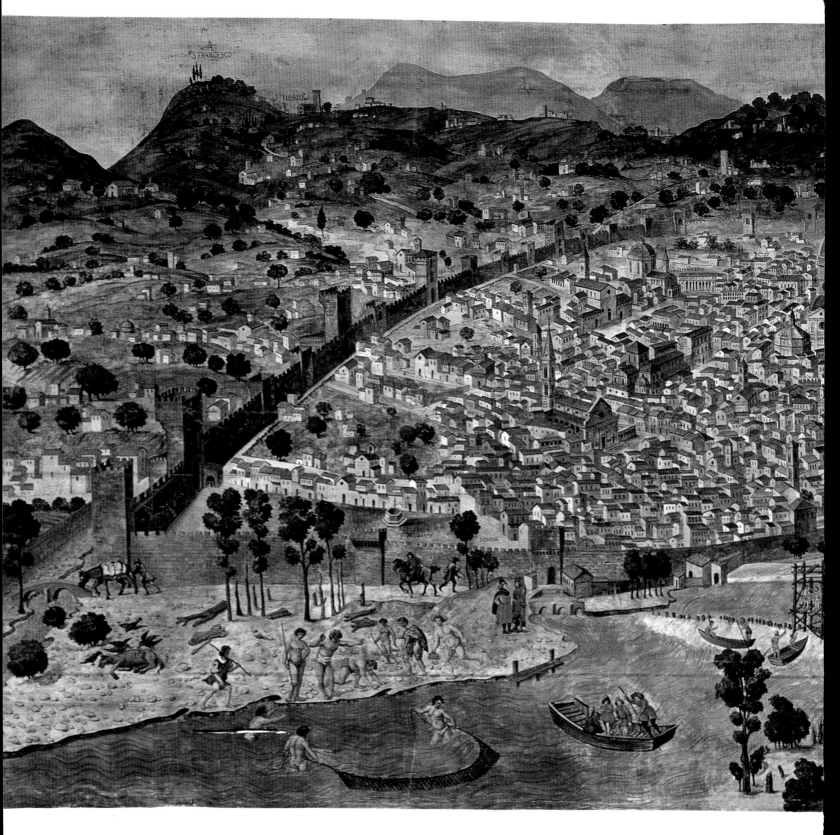

Stefano Buonsignori
View of Florence, known as La Catena,
1470–1490
Museo di Firenze Com'era, Florence

A view of the town that was the cradle of the
Renaissance. To the north of the Arno lies the
old town, surrounded by the city walls, above
which rises Brunelleschi's dome. To the south
are the Pitti Palace, Santa Maria del Carmine,
and the suburbs that lie within the walls of
1172.

FIORENZA

93

PAGE 95:
Daniele da Volterra
Bust of Michelangelo, 1565
Casa Buonarroti, Florence

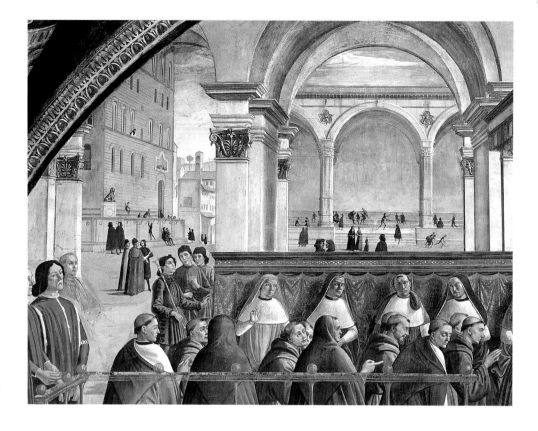

Domenico Ghirlandaio
The Confirmation of the Rule, ca. 1485
Fresco
Capella Sassetti, Santa Trìnita, Florence

To the left is the Palazzo Vecchio, in front of which the *David* was to stand. Opposite is the loggia dei Lauzi, which was not yet filled with the sculptures it would later house

1526 *Day* and *Night* for the tomb of Giuliano de' Medici.

1529 6 April Michelangelo is appointed governor general of the fortifications of Florence / July-August, mission to Ferrara / 21 September, exile in Venice / November, return to Florence.

1532 Rome, meets Tommaso dei Cavalieri.

1534 Preparatory drawings for *The Last Judgement* in the Sistine Chapel.

1535 Appointed chief architect, sculptor and painter to the Apostolic Court by Paul III.

1537 Bust of Brutus (Florence, Bargello) for Cardinal Ridolfi.

1541 Finishes *The Last Judgement,* decorates the Pauline chapel.

1545 Finishes the *Conversion of Saul,* fresco for the Pauline chapel.

1546 Works on the *Crucifixion of Saint Peter* (Pauline chapel), finished in 1550. September, the Pope entrusts him with the completion of St Peter's in Rome. December, first model for the cupola.

1547 Second model for St Peter's.

1550 *Pietà* for Florence Cathedral, deliberately smashed in 1555.

1555 *Rondanini Pietà,* unfinished.

1557 3rd project for St Peter's.

1561 4th model for St Peter's.

1563 Foundation of the Accademia del Disegno in Florence.

1564 18 February death of Michelangelo.

1518 Birth of Tintoretto.

1519 Death of Leonardo da Vinci.

1520 Death of Raphael.

1523 Death of Gerard David.

1525 (?) Birth of Brueghel the Elder.

1526 Palazzo del Te at Mantua, by Giulio Romano.

1528 Deaths of Grünewald and of Dürer / birth of Veronese.

1529 Death of Andrea Sansovino / birth of Giovanni da Bologna.

1532 François Rabelais: *Pantagruel.*

1534 Death of Correggio.

1533-1540 Rosso decorates François I's gallery at Fontainebleau.

1536 Death of Erasmus (born in 1465).

1540 Deaths of Parmigianino and of Rosso.

1541 Birth of El Greco.

1543 Death of Holbein the Younger.

1546 Death of Giulio Romano.

1549 Du Bellay: *La défense et illustration de la langue françayse.*

1546-1558 Pierre Lescot works on the cour Carrée of the Louvre.

1550 1st edition of Vasari's *Lives of the Artists.*

1555-1560 Château d'Ecouen by Jean Bullant.

1555 Birth of Ludovico Carraccio.

1560 Birth of Annibale Carraccio.

1527 Sack of Rome by the imperial army of Charles V. The Florentine republic is re-established, following the fall of the house of Medici.

1529 Peace of Cambrai (the Ladies' Peace) between France and the Holy Roman Empire.

1530 Fall of the republic of Florence.

1534 Foundation of the Order of Jesus (the Jesuits). Election of Pope Paul III Farnese. Act of Supremacy by which the king of England proclaimed himself head of the English church.

1537 6 January, assassination of Alessandro de' Medici, Duke of Florence.

1538 Ex-communication of Henry VIII of England.

1545-1563 Council of Trent.

1446 Death of François I, who is succeeded by his son Henri II.

1550 Julius III del Monte is elected Pope.

1555 Death of Julius III / Reign of Marcellus II / Election of Paul IV Carafa.

1556 Abdication of Charles V.

1558 Death of Charles V.

1559 Election of Pius IV / François II, king of France.

1560 Charles IX, king of France.

1564 Death of Calvin.

Photo credits

The publishers and the author would like to thank those museums, archivists, collectors and photographers who have supported them in producing this work.

In addition to those persons and institutions cited in the legends to the pictures, the following should also be mentioned:

Studies for the *Ignudi,* ca. 1509

Alinari, Florence: 92, 93

Alinari-Giraudon, Paris: 7, 8 centre, 11 above, 12 right, 16 left, 48, 50, 51, 54, 55, 84, 94

Artephot, Nimatallah, Paris: 82, 83

Courtesy of the Fogg Art Museum, Harvard University Art Museums, Gifts for Special Uses Fund: 1

© Bridgeman Art Library, London: 4, 38

By kind Permission of the Earl of Leicester and Trustees of the Holkam Estate, Norfolk: 21 above

Giraudon, Paris: 80 left, 81

Robert Hupka: 17, 18 left

Lauros-Giraudon, Paris: 56 below

© 1995 The Metropolitan Museum of Art, New York: 43

Reproduced by courtesy of the Trustees, The National Gallery, London: 15 left, 19

© Photo RMN, Paris, R. G. Ojeda: 16 left, above

© Photo RMN, Paris, G. Blot/C. Jean: 18 right

© Photo RMN, Paris, C. Jean: 52 right, 53 left

© Photo RMN, Paris, Michèle Bellot: 53 below right

© Photo RMN, Paris, G. Blot: 53 above centre, 78, 87, 90

© Photo RMN, Paris: 53 above right

© The Royal Academy of Arts, London: 13 left

The Royal Collection © Her Majesty Queen Elizabeth II, Windsor: 61, 62, 63

Scala, Istituto Fotografico Editoriale S.p.A., Antella (Firenze): cover, 6, 10, 11 below, 12 left, 14, 15 right, 56 centre, 58 below, 60, 86, 91, 95, back cover

© Teylers Museum, Haarlem: 2, 20, 39

Photo Vatican Museums, Rome: 22, 24, 25, 26, 27, 28, 29, 30–31, 32, 33, 34–35, 36, 37, 40–41, 42, 44–45, 46, 47, 64, 67, 68–69, 70, 71, 72, 73, 74–75, 76, 79

The author would also like to thank Bea Rehders and Veronica Weller for their indispensable assistance with picture research.

Index of names